Art Escapes

Daily Exercises and Inspirations for Discovering Greater Creativity and Artistic Confidence

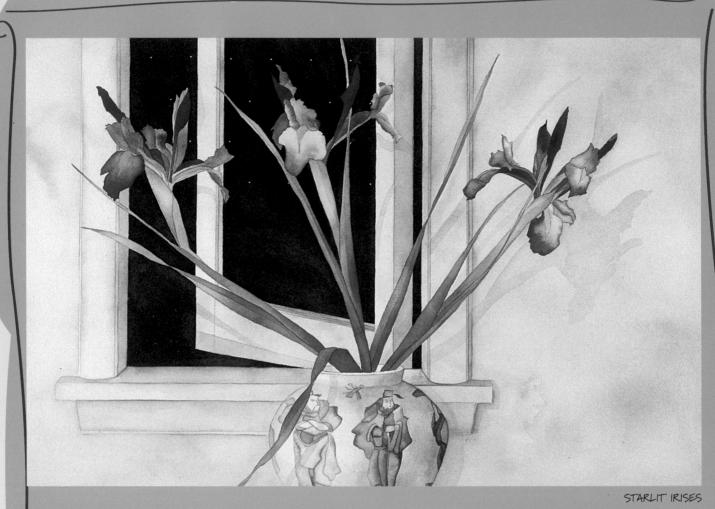

STARLIT IRISES
Watercolor on Arches 140-lb. (300gsm) cold-pressed paper
17° × 28° (43cm × 71cm)
Collection of Ellen Rosenbaum and Richard Meeker

& CArt Escapes

Daily exercises & inspirations for discovering greater creativity & artistic confidence

倒

Dory Kanter

About the Author

Dory Kanter earned her master's degree from Reed College and is a noted artist in the American Northwest. A member of the Watercolor Society of Oregon since 1985, she is the recipient of many awards and juried honors. Her work is found in private and corporate collections throughout the United States and overseas. She is the illustrator of three creative educational CD-ROMs, and a children's book, *The Bear and the Blackberry*. While on sabbatical with her family, she lived for a year in China and a year in Greece, and exhibited extensively while abroad. She teaches painting and journaling workshops throughout the Pacific Northwest. Dory has a well-earned reputation for being a motivating art teacher; her workshops speak to and inspire beginners as well as experienced professional artists. In 1995, she founded Art World Tours, and has conducted painting tours to Provence, Corsica, Italy, China, Greece and Turkey. Her work is shown in Portland, Oregon, at her studio and at the Portland Art Museum sales gallery. Visit her website at www.dorykanter.com.

PHOTOGRAPH BY COLLEEN CAHILL

Art Escapes. Copyright © 2003 by Dory Kanter. Manufactured in China. All rights reserved. No part of this book may be reproduced in any form or by any electronic or mechanical means including information storage and retrieval systems without permission in writing from the publisher, except by a reviewer who may quote brief passages in a review. Published by North Light Books, an imprint of F+W Publications, Inc., 4700 East Galbraith Road, Cincinnati, Ohio, 45236. (800) 289-0963. First UK Paperback Edition 2008.

Other fine North Light Books are available from your local bookstore, art supply store or direct from the publisher.

12 11 10 09 08 5

5 4 3 2 1

Library of Congress has catalogued hardcover edition as follows:

Kanter, Don

Art Escapes : daily exercises and inspirations for discovering greater creativity and artistic confidence / Dory Kanter.— 1st ed.

p. cm

Includes index.

ISBN-13: 978-1-58180-307-5 (hc.: alk. paper)

ISBN-10: 1-58180-307-9 (hc.: alk. paper)

ISBN-13: 978-1-60061-200-8 (pbk.: alk. paper)

ISBN-10: 1-60061-200-8 (pbk. : alk. paper)

1. Art—Technique. 2. Notebooks. I. Title.

N7430.5.K35 2003 702'.8—dc21

Edited by James A. Markle Designed by Wendy Dunning Production art by Christine Long Production coordinated by Mark Griffin 2003042075

METRIC CONVERSION CHART

To convert	to	multiply by
Inches	Centimeters	2.54
Centimeters	Inches	0.4
Feet	Centimeters	30.5
Centimeters	Feet	0.03
Yards	Meters	0.9
Meters	Yards	1.1
Sq. Inches	Sq. Centimeters	6.45
Sq. Centimeters	Sq. Inches	0.16
Sq. Feet	Sq. Meters	0.09
Sq. Meters	Sq. Feet	10.8
Sq. Yards	Sq. Meters	0.8
Sq. Meters	Sq. Yards	1.2
Pounds	Kilograms	0.45
Kilograms	Pounds	2.2
Ounces	Grams	28.4
Grams	Ounces	0.04

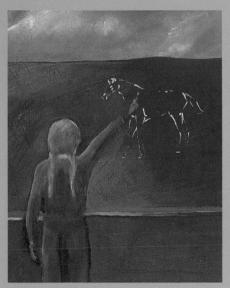

Self-Portrait: Discovery, Inspiration and Resilience

A Note From the Author

Several years ago at a painting workshop, a student asked me a thought-provoking question. She wanted to know if it was difficult for me to let go of my paintings. I told her that I love when people enjoy my paintings in their homes and offices, but my artistic journals are different. I would never let go of them. They are a personal, private legacy I like to keep close by me. I was quite surprised by the strength of my emotion as I said this! At that moment I became vividly aware that my daily artistic journals ground me, comfort me and inspire me.

The freedom I feel in my journals reminds me of the playful way I entered the world of art. When I was eight years old, I discovered the miracle of mixing red and blue paint. The self-portrait on the left shows me making finger outlines of horses in the night sky with my newly discovered purple. Whether you're eight or one hundred and eight, I hope the creative exercises in this book will help you to discover the joy of creating personal art, every day.

Dedication

This book is dedicated to my mother who showed me how life is enriched by art. Her hands were always creating beauty: spirited piano music, handmade clothing for me and my dolls, quilts, china paintings, ever-evolving gardens, and food that warmed the body and heart.

DORDOGNE VILLAGIE HOUSE Watercolor on Arches 140-lb. (300gsm) cold-pressed paper 27" × 20" (69cm × 51cm)

Acknowledgments

First of all, my heartfelt thanks go to my husband, Steve, for believing. You sweetly tolerated my long hours at the computer and studio, faithfully guarded my quiet work time and never wavered in your confidence in me. Thank you to my cherished children, Jordan and Laura, for your constant encouragement. You both inspire me by example to escape the ordinary.

I want to thank my loyal circle of friends who guided me, supported me and cheered me on during the writing of this book. Thanks to each of you for understanding all the times when I couldn't come out and play! I want to especially acknowledge my friend, Kelley Petkun, whose enthusiasm, creativity and wit helped me launch this project. A big hug and thank you to my dear friend, Andrea Baker, who always made time and always found the diamonds in the rough drafts. Special thanks to Rick Samco, who got me over my photography phobia. Much appreciation to Bob Cantor for answering my phone calls with burning questions, day and night. Lots of love to Bill Baker for nourishing my soul with the world's best barbecued chickens. And many thanks to Karin Harris, studio partner extraordinaire, for your dancing paint brush and spirit.

I want to thank the contributing artists, Jeanne Henry, Gary Hang Lee, Sue Greenbaum, Karin Harris, Ann Smith, Robert Cantor, Monica Wheeler and Laura Kanter for generously sharing your artistry and incredible ideas with me. My gratitude also goes to my CD buddies, Bob Dylan, Sade, the Grateful Dead, Miles Davis, J.S. Bach, Maurice Ravel, Paul Simon, Bob Marley and Josh Groban who provided musical companionship in the studio.

Many thanks, Rachel Rubin Wolf, for seeing the light of a book in my work, and helping me find the right focus and direction. And, finally, boundless gratitude to my wonderful editor, Jamie Markle, who gave me advice when I needed it, always trusted in me, and gently guided me through the process of creating this book. You unfailingly encouraged me to show my true colors and write the book within me. I could always count on your humor, patience, compassion and wise answers to a million questions. Thank you, Jamie!

Table of Contents

Introduction 11

Secrets to Successful Artistic Journaling
12

Assemble Your Supplies for Creativity 14

Sketchbook Portfolio
 Demonstration: Make a
 Sketchbook Portfolio
 Drawing Tool Kit

 Collage Tool Kit
 Watercolor Tool Kit
 Demonstration: Make Your Own Tool Kits

Opportunities for Everyday Creative Moments 40

2 Have Fun and Keep It Simple 22

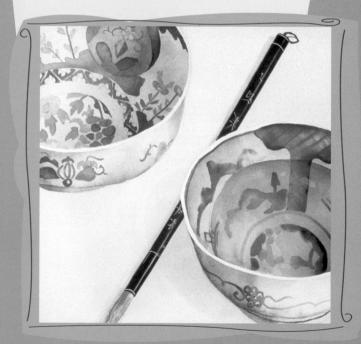

4 Putting It All Into Perspective 58

Bird's-Eye View
Demonstration: Make a Garden
Piazza Perspective
Demonstration: Paint With
Perspective
Leave Out a Ground
Make Seven
Paintings From One Landscape
Panoramic
Perspective
Demonstration: Make a Panoramic
Viewfinder
Demonstration: Create a

Folded Frame for Your Panoramas
The Sensory Perspective

■ Panoramas
The Sensory Perspective
■ ■ Panoramas
■ The Sensory Perspective
■ ■ Panoramas
■ The Sensory Perspective
■ ■ Panoramas
■ Panoramas

5 Art Assemblage, Collage & Other Inspiring Ideas 78

✓ Watercolor Mosaics
 ✓ Use Black or Colored
 Backgrounds
 ✓ Add Texture Using Special Effects
 ✓ Demonstration: Dry Mount Glue Technique
 ✓ Painted Paper Cutouts
 ✓ Demonstration: Create a
 Colorful Background Blanket
 ✓ Paper Weaving
 ✓ Weave a Wavy Memory
 ✓ Weave Two Themes
 Into One Subject
 ✓ Crinkled Paper Collage
 ✓ Demonstration: Rich Color and Texture
 ✓ Found Object Collage

Conclusion: Be an Art Explorer 125

6 Let's G10 Ovtside and Paint! 100

 ✓ Inspiration: The First Step
 ✓ Shape Plan: The Second Step
 ✓ Value Plan: The Third Step
 ✓ Using a Red Filter to See Values
 ✓ Moving From Landscape to Painting

 ✓ Color: The Fourth Step
 ✓ Capture the Mood With Color Triads
 ✓ Triads Have Personality!
 ✓ Get to Know the Full-Spectrum Triad
 ✓ Get to Know the Earth Triad
 ✓ Cet to Know the Earth Triad
 ✓ Get to Know the Water Triad
 ✓ Get to Know the Sun Triad
 ✓ My Color Palette
 ✓ Perfect Complements Create Perfect Blacks
 ✓ The Palette Layout
 ✓

Introduction

The more I draw and paint, the more I value what I call private art—daily creative exercises in my artistic journal. They are an account of ideas, questions, dreams, explorations and experiments of the hand and the heart. They are a witness to an awakening to the full spectrum of ordinary life. They mirror the gentle stirrings of the eye, mind and soul. And, they are done with no thought of public viewing.

I believe there are two purposes for keeping an artistic journal. First, you want to record personal sensations, whether at home or away. And, secondly, you will accumulate a cache of remembrances to develop further, if you choose. The important thing is to do at least one page each day. Write all over the page, or not at all. Use color, or shades of gray. Use pencil, pen, collage or watercolor. Make quick notations or fully developed paintings.

Many years ago, my son's four-year-old playmate asked me what I had done that day. I told her that I painted a flower. "Oh," she said, "wasn't it pretty enough already?" Her fresh and natural response delighted me. She had the enviable gift of still being startled by life. One of the joys of being an artist is an excuse to look at life closely, and to nurture a sophisticated innocence. The replenishing solitude of my journaling practice revives my own four-year-old beginner's eyes.

Try a different *Art Escapes* project every day. This is an idea book of creative exercises organized to make it easy to have success making art—wherever and whenever. The only rule for the artistic journalist is that there are no rules. Results are not important, creativity and innovation are. Cultivate a curiosity of the ordinary and a passion for everyday life. Give wings to your playful creativity with *Art Escapes* in your own artistic journal!

The palest ink is better than the best memory.

Confucius

Secrets to Successful Artistic Journaling

A journey of a thousand miles begins with a single step. ~ Confucius

A journal of a thousand images begins with a single page. Reframe everyday activities into artful expressions in your artistic journal. Gently filter art into your life at the same time you build a momentum of artistic confidence. Stop, relax and claim a moment each day for creativity. My artistic journal practice helps me isolate moments of awareness, and the creative avenues to reveal them.

How to Make Art Everyday

Make it your personal practice to create a page in your journal—each day. It can be a sketch, a collage, a poem, a quote, a memory or any combination that fits your mood. Research shows that if you do something consistently for a month, it can become a habit. Who doesn't want to develop an art habit?

Honor an Event

Fill a page to mark an occurrence, an encounter or moment that is important to you—whether contemporary or past, private or public, with or without explanatory text.

QUANTITY EQUALS QUALITY—In my experience, the more you paint and draw, the more your skills of expression grow and blossom. Your artistic journal is the perfect place for permission to paint and draw without judgment. It's simple: The more you do, the better you get. Rather than getting stuck focusing on perfect results, focus on having fun filling up the pages of your journal.

Journal Buddies—Share your journal with friends. I get together with a group of journal artists once a month. We show each other what images we've each put into our artistic journals during the month, encourage each other's efforts and share great new ideas.

Admire Your Journal—Open your artistic journal and admire past pages. It's marvelous to see what pops up in the messages you send to yourself. At the heart, your artistic journal is a letter to yourself, slowly revealing itself over time. Open your journal, and savor the spontaneous field notes of your life.

Commit Random Acts of Art—Turn to any project in this book, and give it a go. You might surprise yourself with a memorable journal entry, even if you believe you have no known painting or drawing skills. Uncover and discover your inner artist.

ESTABLISH A DAILY RHYTHM—Are you a morning, afternoon or evening journal person? Notice the rhythm and pattern of your entries. Do you tend to prefer a specific time of the day? If so, structure your day around your creative patterns.

I have a friend who loves to journal late at night, when the day is over and she can quietly reflect. I prefer to journal first thing in the morning to clear my head and heart for the day. Travel to your own artistic drumbeat.

Go Places and Explore—Have you always wanted to see a stone quarry? The dismantling of a circus tent? A city from the top of a skyscraper? Go ahead and satisfy your curiosity. You have the perfect excuse—you're an artist.

BE SITE SPECIFIC—Art makes you more receptive to the world around you. Draw, paint and write about what you see, smell, taste, hear and feel, wherever you are. The biggest secret to artistic journaling is to relax and open your heart and mind to what is in front of you right now.

How to Get Started

The best way to get started is to adopt the page-a-day journaling approach. Liberate yourself from the pressure to perform. Instead, relax and let yourself play. I've found that one page often leads to another page or to a larger work of art. Make note of what gets you going and establish your own personal rituals. Brew a cup of tea; put on some music; light a candle. Then, open your journal and have fun.

Assemble Your Tool Kits and Portfolio—Make it easy to indulge your creative impulse by having your supplies ready. Chapter one will explain what you need with full details and step-bystep instructions.

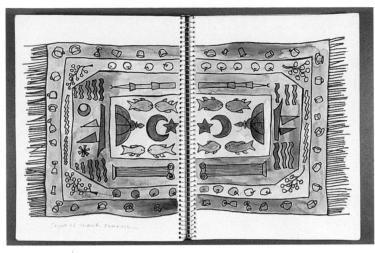

Design Facing Pages

Think of your journal as a book that is created as a series of facing pages. I often use double stick tape to adhere two pages together, in case the previous page has buckled as a result of using watermedia or if ink marks show through the paper. This journal entry is a painted *carpet* of Turkish memories, made on the airplane ride home while my impressions were still fresh. Using facing pages gives me room to record more images in my designs.

Start Each Journal With a Frontispiece—Reserve the first page of your journal to record your name and the date. I always put a note at the bottom of the first page, with my phone number, asking that my journal be returned to me if lost.

ADD A SECTION FOR LISTS—I dedicate the last four pages of each of my journals for notes, suggestions and bits of information I want to remember.

These pages are saved for lists of miscellany—books to read, art supplies to try, places to go, CDs to buy, restaurants to try.

How to Find Time

What does it mean to have time to create art? It means learning to slow time down by paying close attention to life's everyday details. Making art is a wonderful way to fill your sails

Decorate Your Journal Cover

Embellish your journal cover with docorative paper, a painting or a collage. Celebrate the miracle of uniqueness in each of your journals. You'll be surprised how quickly they will accumulate.

with the fullness of each available moment. Here are some strategies to help you find time for art everyday.

PLAN FOR CREATIVITY—Sit down every Sunday evening and look ahead in your schedule to anticipate creativity breaks in the coming week. Look for half hours here and there that would normally be squandered, and reclaim it for your art. Identify windows of opportunity in your daily planner for your artistic journal. Use breaks at work to create café art. Refresh your spirit with some creativity, even in the middle of your workday.

Time Expands When You Do Art—The moments seem longer when you are fully focused and your creative self has some breathing room. The elation you feel from taking a creativity break stays with you throughout the day. A half hour

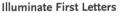

Enlarge the first letter of a written entry. Embellish the letterform in a style reminiscent of medieval illuminated manuscripts. This is a great way to begin a new journal page.

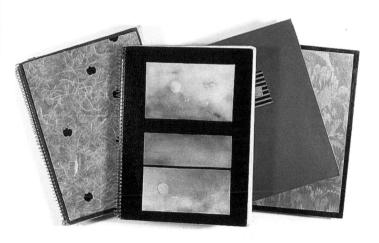

can seem so much more expansive than a mere thirty minutes.

Short Assignments—Limit yourself to the smallest of subjects—the cloud formation of the day, purchase of the day, laugh of the day, phone message of the day, E-mail of the day. Remember, less is more.

Practice Creative Waiting—Open your journal while you wait at the doctor's office for your appointment. I've been known to do a page of one minute drawings while standing in line. I know a journal artist who draws everyday on the subway on his way to work. His journal is filled with drawings of the interesting strangers he encounters on his commute. He comes prepared everyday with his journal, drawing tool kit and hopes for a seat.

CHINESE BRUSHES AND BOWLS Watercolor on Arches 140-lb. (300gsm) cold-pressed paper 9° × 11° (23cm × 28cm) Collection of Jane Endler

Assemble Your Supplies for Creativity

treamline your supplies to free your artistic impulse. Simplicity is often the catalyst for creativity. I keep all my materials in three trim tool kits—one for drawing, one for collage and one for watercolor. I keep my sketchbook and watercolor palette in a light and slender portfolio. It's a breeze for me to grab my three essential tool kits and my portfolio and bring them along with me wherever I go. This practice truly extends my studio out into the world at large.

You cannot govern the creative impulse; all you can do is eliminate obstacles and smooth the way for it.

~ Kimon Nicolaides

You'll never have time for art unless you claim the time. One way to make time is to have your art supplies organized and ready to go. In this chapter, I show you how to make a portfolio case, uniquely designed to fit your own sketchbook. I also show you how to make your own tool kit supply cases, customized to match

your personal choice of materials. The materials you need for the projects in this book are included in the portfolio and three tool kits. The promise of art day-by-day is sewn

into your portfolios and three roll-up cases.

The idea for these tool kits came to me while packing for a trip. After years of travel, I have learned to keep my toiletries case pre-packed. I don't worry about remembering my toothbrush because everything is already there. Having a compact and complete set of art supplies ready to go propels creativity by eliminating packing obstacles. Make a quick transition from the responsibilities of life into a creative moment in your artistic journal simply by having all your materials portable and ready for action.

Although I have a studio, it is not the only place I create

Although I have a studio, it is not the only place I create art. At our cabin on the Metolius River in Oregon, I paint and draw at the kitchen table, outdoors by the river or even

on a mountain hike. I am often on the road, overseas in foreign countries, teaching workshops or visiting friends and family out of town. Like you, I must attend meetings, and cool my heels in waiting rooms and airport lobbies. But, wherever I am, I am confident I have everything I need for everyday *Art Escapes* in

my artistic journal.

Sketchbook Portfolio

Keep your sketchbook in an easy-to-make portfolio. I designed this portfolio to hold my favorite sketchbook, the Aquabee 9" \times 12" (23cm \times 30cm) spiral-bound sketchbook. I have filled more than twenty of these books so far, and plan to keep on going. I am drawn to this size because it gives me enough room for my drawings, paintings and collages, yet is still very portable. You can easily alter the dimensions of the pattern if your current sketchbook is a different size. One of the most important features of a great sketchbook is

spiral binding, so the pages lie flat when open. Good, durable paper that takes a lot of abuse is also an essential. The Aquabee sketchbook accepts water media, as well as pen and pencil, surprisingly well.

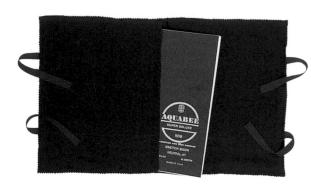

Make a Portfolio for Creative Portability

This folded portfolio is a compact way to carry and protect your sketchbook, as well as other essentials for painting and collage. And it is fun to make. I slide my sketchbook into one side, and everything else fits neatly into the other side.

Watercolor Palette

I tuck my watercolor palette into one side of my portfolio. The Jones Color Round palette is compact enough to fit inside my portfolio and it has all the features necessary to make watercolor paintings whether large or small.

Values Filter

Clear, red acetate taped inside a 5" x 7" (13cm x 18cm) mat is an effective aid for distinguishing tonal values, especially when viewing the landscape. Refer to chapter six for a complete explanation.

Drafting Tape

A roll of drafting tape to secure and tape off the edges of watercolor paintings.

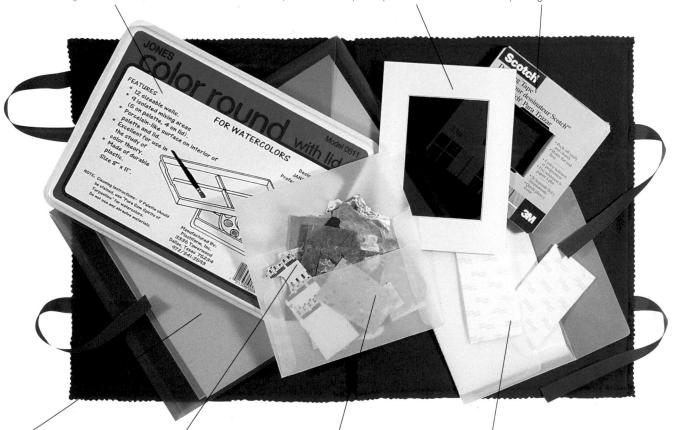

Watercolor Paper

Pieces of Arches 140-lb. (300gsm) cold-pressed watercolor paper in various sizes, cut to fit my sketchbook.

Collage Papers

A variety of decorative papers for collage in a $9\frac{1}{2}$ " x 13" (24cm x 33cm) clear plastic envelope.

Paper Scraps

Small pieces of decorative papers, ticket stubs, stamps and paper scraps for collage work.

Mounting Tabs and Laminating Paper

Double stick mounting tabs and clear laminating paper for use in collages.

Make a Sketchbook Portfolio

MATERIALS

Felt One 14" x 22" (36cm x 56cm) piece Two 14" x 101/2" (36cm x 27cm) pieces Grosgrain ribbon Four pieces, 5/8-inch (12mm) wide, 8 inches (20cm) long

Needle and thread or fabric glue

Pencil

Pinking shears

Pins

Spiral bound sketchbook 9" x 12" (23cm x

Straightedge or ruler

At the fabric store, you will find bolts of polyester craft felt in a spectrum of colors. For a 9" × 12" (23cm × 30cm) sketchbook, you will need one piece of felt measuring 14" × 22" (36cm × 56cm). You will also need two pieces of felt, each measuring $14'' \times 10^{1/2}''$ (36cm × 27cm). Make adjustments to the dimensions if your current sketchbook is not $9'' \times 12''$ ($23 \text{cm} \times 3 \text{ocm}$) in size.

It is not necessary to use pinking shears, as felt will not unravel even if cut with regular scissors. However, I like the finished look of the zigzag edge. If you prefer, you can use fabric glue rather than sewing.

Cut Three Pieces of Craft Felt

Use pinking shears to cut one piece of felt measuring $14" \times 22"$ (36cm × 56cm) and two pieces of felt, each measuring 14" \times 10½" (36cm \times 27cm). Be sure to make adjustments to the dimensions if your current sketchbook is not 9" \times 12" (23cm \times 30cm).

Place the Two Smaller Pieces on Top of the Larger Piece

Place the two smaller pieces of felt on top of the larger piece, leaving a 1-inch (25mm) gap between them in the middle of the large piece of felt. This gap allows for the width of the sketchbook and palette when the portfolio is folded in half. Cut four 8-inch (20cm) pieces of 5/8-inch (12mm) grosgrain ribbon. Tuck the ribbon pieces between the top and bottom layers of the fabric, on each side, as shown. Pin all the materials in place.

Sew or Glue the Edges

Sew (or glue) around all the sides 1/4inch (64mm) from the outside edge, as shown, leaving the inner edges of the small pieces of felt unsewn so that they form pockets.

Drawing Tool Kit

All I need for drawing is rolled up into this colorful little bundle. I've refined my selection of tools over time to identify just the supplies I need—no more and no less. I always plan with portability in mind and these tools are my drawing essentials. I know that my purple pouch has all my drawing supplies—collected, organized and ready for action. It's an invitation to dive into my artistic journal!

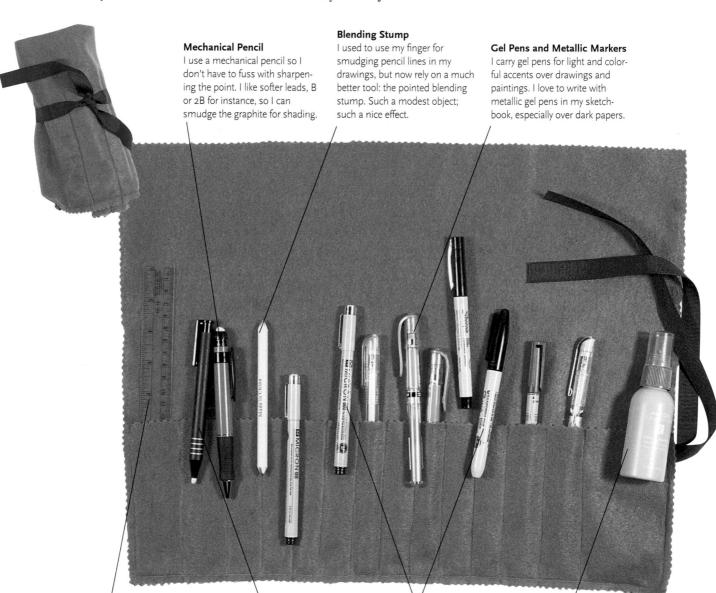

6-Inch Straightedge

I tuck a small 6-inch (15cm) plastic ruler into my drawing kit. It comes in handy to draw straight lines, as an erasing shield, to texture my watercolors and, occasionally, to measure.

Click Eraser

I always carry a pencil-style white eraser stick. I especially like ones with a small erasing diameter, perfect for touch-ups both big and small. The ones that click to push out the eraser are easy to load.

Felt Pens

I always have a small stash of felttip pens in different sizes and colors. The Pigma Micron pens are permanent waterproof India ink. I like pens with both fine .35mm and wider .50mm pen widths. I also like both the Sharpie fine and ultra fine point pens that are also permanent. Sepia Staedtler Lumocolor pens are great, too. They are nonpermanent and the lines soften when brushed with water over top of a drawing.

Fixative

A small plastic container of non-aerosol hair spray is a key feature in my drawing tool kit. Pencil drawings and writing will smear, and leave traces on the facing page, if they are not coated with a fixative. Hair spray works fine and has the added benefit of being nontoxic, unlike commercial fixatives. Look for small bottles of hair spray in the travel section of cosmetic and drugstores.

Collage Tool Kit

Everything you need for creating collages is included in this tool kit. A few well-chosen supplies consistently do more for your creativity than a room full of supplies you don't use. This yellow bundle, wrapped with a purple ribbon, entices me to open it, and have fun making collages in my sketchbook. Choose lively colors of felt and ribbon—why not put color into your art supply cases? You'll see how to use these supplies to create an exciting array of assemblages and collages in chapter five.

Glue Brush

I keep a worn-out brush in my collage tool kit to use when applying white PVA glue. I don't want to ruin my good watercolor brushes by using them to brush on glue.

White Glue

Include a small plastic container of white PVA glue. Be sure it is acid-free to protect your artwork. There are a number of white glues on the market; they all dry clear and are permanent. I pour a small amount of glue into a plastic container with a pouring spout, purchased separately.

Metallic Pens

I love the Krylon gold and silver leafing pens. They add an extra sparkle and dimension to collages.

Rubber Cement Pick Up

This small square picks up dried rubber cement and cleans up any errant spots of glue.

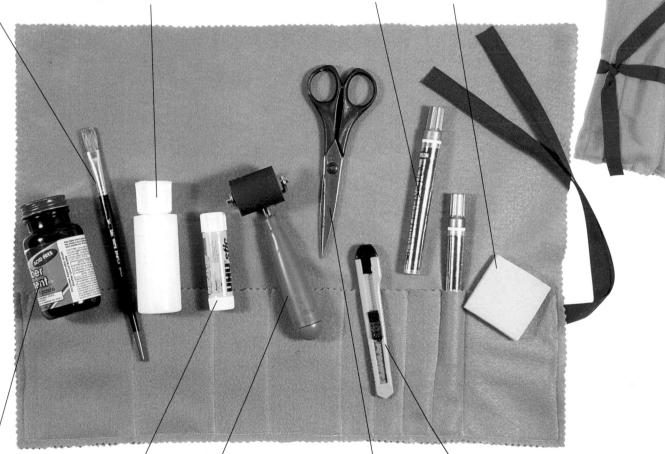

Rubber Cement

A small plastic container of acidfree rubber cement makes collage work easy and fun. The bottle of glue comes with a brush for easy application. Be sure to buy rubber cement that is acid-free for the preservation of your artwork.

Glue Stick

An acid-free glue stick is invaluable for collage.

Brave

A small 1½-inch (38mm) brayer helps flatten pieces of paper in the gluing process, especially when making crinkled paper collages.

Scissors

A small but sharp pair of scissors is essential to collage work.

Craft Knife

Sometimes it's hard to cut small pieces of paper with a pair of scissors and the craft knife can do the job nicely.

Watercolor Tool Kit

This selection of supplies is a comprehensive collection of what I consider the essentials for watercolor. I recommend felt for my supply case design because it is a highly absorbent material and perfect for soaking up dampness from brushes or other watercolor tools. This red roll-up case invites me to paint. I know it has all I need to get started, and keep going. All I need to do is take my journal and watercolor palette out of my portfolio, unroll my watercolor tool kit, and start playing in full color.

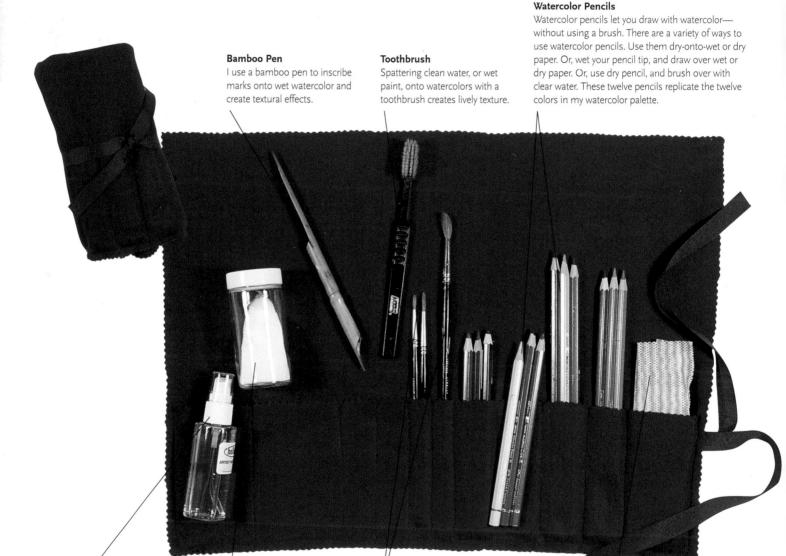

Spray Bottle

A small plastic spray bottle of water is an essential for many watercolor effects. Also, I spray the paints in my palette to wet them before painting.

Salt Shaker

Sprinkling salt onto wet watercolor creates a great special effect.

Rrushes

Three round brushes, nos. 2, 4 and 6, are all I need for painting in my artistic journal. I love to paint with kolinsky sable brushes because they are so responsive and hold a lot of water. However, synthetic brushes, or ones with a mixture of synthetic and natural fibers, are less expensive and work quite well.

Disposable Dish Towel

These disposable dish towels, available at the grocery store, are super absorbent. Instead of paper towels, I've found that one of these dish towels is all I need to keep my brush tips dry and to dab up puddles.

Make Your Own Tool Kits

MATERIALS

Felt One 14" × 18" (36cm × 46cm) piece
One 5" × 18" (13cm × 46cm) piece
Grosgrain ribbon two pieces, 5/8-inch
(12mm) wide, 12 inches (30cm) long
Needle and thread, or sewing glue
Pencil and straightedge
Pinking shears
Pins

Make a supply case that fits your supplies, instead of the other way around. I have a bunch of zippered cases, brush holders, portfolios, carriers and totes in all sizes and shapes that almost work for me. But the only way for me to get exactly what I need is to make it myself. I designed this easy-to-make roll-up supply case for my three essential tool kits—one for drawing, one for collage and one for watercolor. Choose different colors for each of them for quick identification. All I do to make art is grab and go. My friends love when I make a colorful supply case for them as a gift.

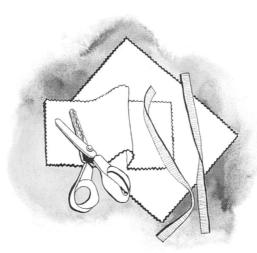

1 Cut Two Rectangles of Craft Felt

Cut one piece of craft felt into a 14" × 18" (36cm × 46cm) rectangle using pinking shears. Cut a second piece of craft felt into a 5" × 18" (13cm × 46cm) rectangle with the pinking shears. Next, cut two pieces of 5%-inch (12mm) grosgrain ribbon 12-inches (30cm) long.

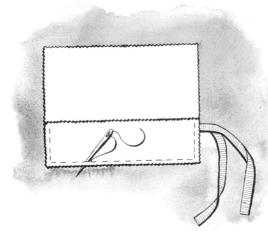

Sew the Sides and Bottom Edges

Place the smaller rectangle of felt on top of the larger rectangle as shown and pin together. Tuck the ends of the ribbons between the larger and smaller rectangles, on the right edge, close to the top of the small piece of felt and pin together. Sew (or glue) along the two vertical sides and bottom, ¼-inch (64mm) from the edges, as shown.

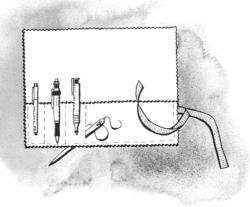

Make Pockets for Each Tool

Place your tools on top of the supply case and mark where you want to create a pocket. Use a ruler to make a straight line. Sew (or use fabric glue) along the vertical lines to create slit pockets to accommodate your tools. A good rule of thumb is to allow a 1-inch (25mm) width for the average pen or pencil, adjusting as needed for the size of your tools.

Have Fun and Keep It Simple

Every child is an artist. The problem is how to remain an artist once he grows up.

~ Pablo Picasso

DKanter

hen I was little, I drew everywhere—on scraps of paper, on my walls, in the night air with my finger. It was magical. Today I keep that spirit of pure joy alive in my sketchbook. This is where I play with paint and create drawings for enjoyment alone. My sketchbook habit is an oasis in my day, a way for me to savor the moment.

Experiment this month by taking your sketchbook with you everywhere you go. In this chapter, I give you suggestions for illuminating your daily life in draw-

ings and paintings that are simple and fun. I show you how to sketch and paint at a cafe', on the road and at meetings. You will see how to create a journal page a day in many different kinds of ways, and in unexpected places.

All the painting projects in this chapter use only three pigments—my versatile full-spectrum triad. A few well-chosen art supplies make it easy to explore artistically each day. Remember: the world is your best studio.

WATER PATTERNS
Watercolor on Arches 140-lb. (300gsm) cold-pressed paper
22* × 30* (56cm × 76cm)
Collection of Carol and Edwin Wright

One Minute Drawings

Prepare Your Journal

Prepare your journal by drawing six little boxes on a page—hand drawing is fine, there is no need for a ruler. Each little box should be roughly 2" × 2" (5cm × 5cm), drawn with a 2B pencil. Now you are ready to fill them in with quick small frame impressions of whatever catches your eye. Those six little empty boxes will inspire you to fill them up!

Sketching is fun—especially when doing one minute drawings. Draw a page of little sketches, and leave the editing and erasing out of the picture. Experiment with both the small frame and open page formats to see which enhances your sense of freedom and creativity. When you first begin, time yourself or enlist the aid of a friendly timekeeper. I do a few thirty-second drawings to warm up. You will be surprised by how long a minute seems after that. Let your eyes do the drawing for you. Keep your gaze on the object more than on the paper in front of you. Don't expect finished drawings. This is the art of the rough sketch. You will get better and better at capturing the essence of a scene or subject in just a short amount of time. Remember, let yourself draw without judging. The art critic is on vacation. Draw quickly and draw often.

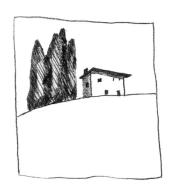

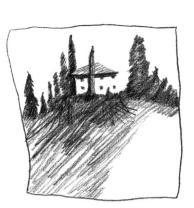

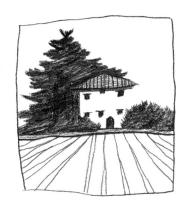

island and water changed rapidly. Be sure to make the little boxes on your page first, so you can draw in each one in quick succession.

Small Frame Format

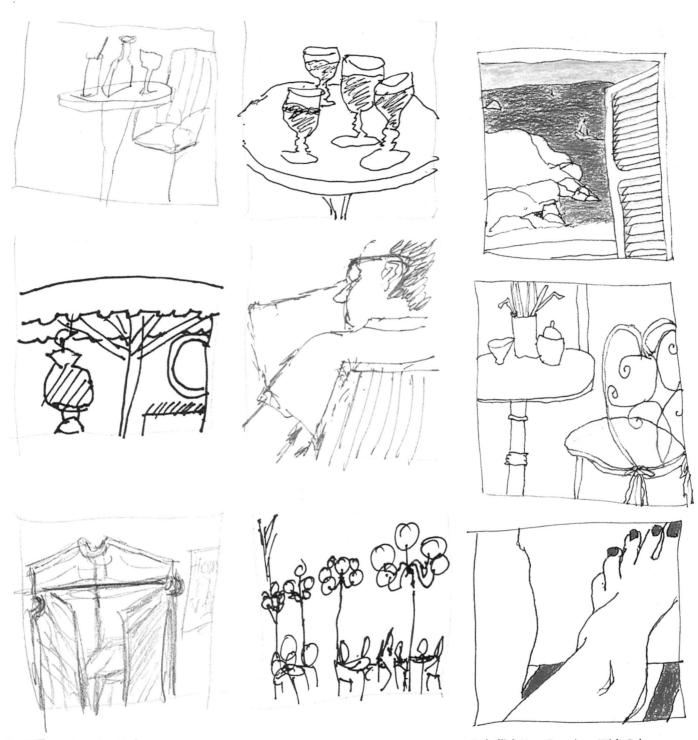

Try Different Drawing Tools

Take a look at one of my workshop student's first attempts at one minute drawings. She decided it was reassuring to have the structure of the small frame format. She experimented with several drawing tools—pencil, black felt-tip pen and red ink pen—to see which appealed to her the most.

ONE MINUTE JOURNAL DRAWINGS Jeanne Henry Pen and pencil on journal paper 8° × 10° (20cm × 25cm)

Embellish Your Drawings With Color

Jeanne continued to work in the small frame approach in more one minute drawings. She was so pleased with her efforts that she embellished these with colored pencils. It was a joy to see her drawing confidence increase with her new one minute drawing habit.

ONE MINUTE JOURNAL DRAWINGS IN COLOR

Jeanne Henry Pen and pencil on journal paper 8" × 10" (20cm × 25cm)

Open Page Format

Scatter quick sketches all over the page, without confining them to drawn borders. Some of your sketches may overlap others. Draw some subjects close up and some from far away. There is no need for perspective consistency in the open page style. It all adds to the fun. Draw for enjoyment! I promise you will never forget the place or subject you stop for just one minute to draw.

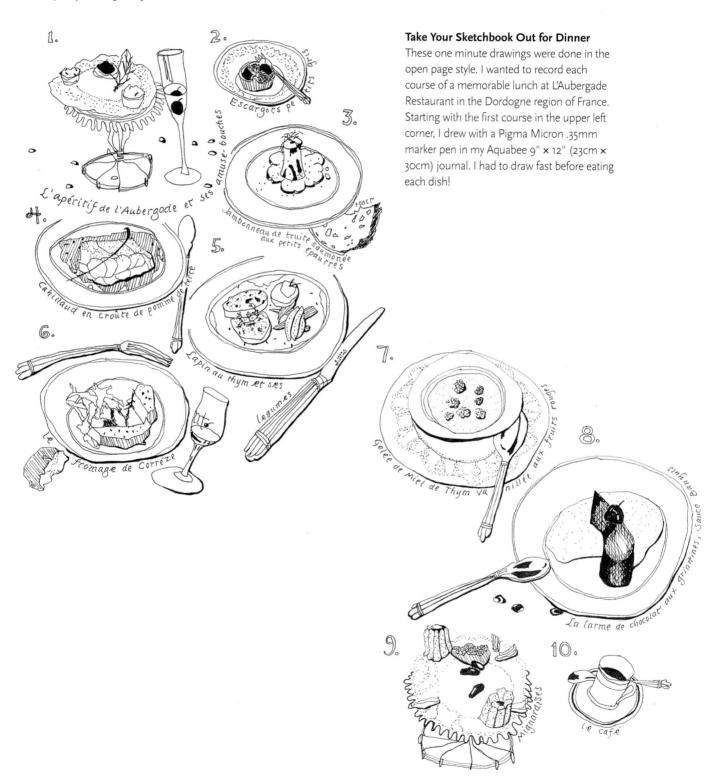

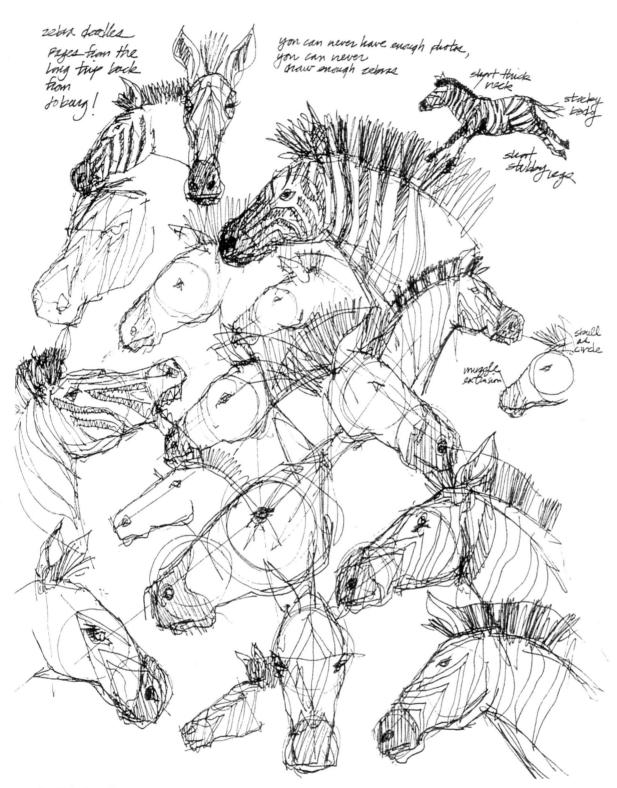

Overlap Your Drawings

Gary Hang Lee's sketchbook on safari to Botswana is filled with open page one minute drawings of wildlife in their natural setting. He doodles with felt-tip pens in a delightful combination of drawings and text. His page is completely covered with quick studies creating a vibrant jungle of images that reflect the richness of his experience. You can almost feel his excitement.

SAFARI SKETCHBOOK DRAWINGS Gary Hang Lee Pen on journal paper 9° × 12° (23cm × 30cm)

Don't Bother With Erasing—Who's Got Time?

I notice that when I let go of trying to make a perfect drawing, I relax and enjoy myself. And, as a result, my sketches are full of life and personality. They become a reflection of the swirl of life around me. In my artistic journals, I want to record rapidly what I see. I especially like to use these three sketching techniques because they encourage no erasures. They release you from the temptation to seek perfection. Try each of these one minute drawing methods. They will help you fill your artistic journal with lively and whimsical interpretations of your day.

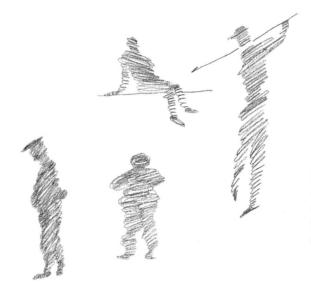

Loop Drawing

I like to draw people in motion using only loops, again without lifting the pencil off the page. Loops are stacked on top of loops to form the shape. These loops give a sense of weight and volume to the figure. Learn to draw people quickly—people like to move. The most interesting people are usually in the act of doing something. Drawing with loops will help you to capture them. These examples were drawn with a 2B pencil.

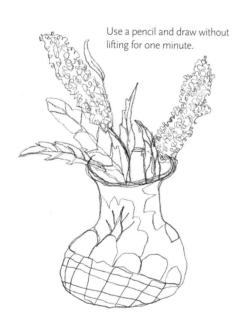

Draw Without Lifting

Pick a subject and draw it without lifting the pencil or pen off the paper. You will crisscross over lines and retrace your steps—that's fine. Give yourself a pencil with a lot of lead so you don't run out in midstream. Darken lines by going over them several times to reinforce shapes. As you go over the lines you want to emphasize, your subject will emerge out of the tangle.

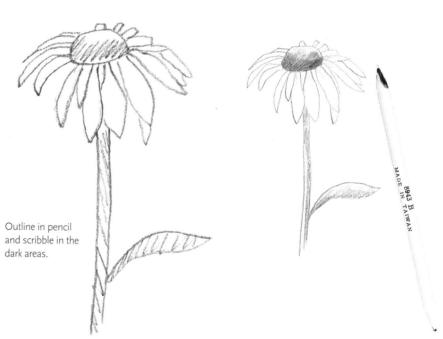

Smudge Shading

Outline your subject with a soft pencil like a 2B. Then scribble in a few lines to indicate dark areas and shadow areas. Use a blending stump to smudge these lines into a blurred gray tone. I have used my finger to smudge on occasion, but a blending stump works much better. You can give a very simple drawing a lot of character with a little shading.

Smudge with a blending stump to create shaded areas.

Turn One Minute Drawings Into Paintings

"My sketchbook serves me as a cookbook when I am hungry. I open it and the least of my sketches can offer me material for work."

~Georges Braque

One of my secrets is to use one minute drawings to jumpstart myself into opening my journal and start to sketch. I tell myself I am only going to spend one minute per sketch, six on a page—that's only six minutes of my busy day. The truth is that as soon as I get going, I want to keep on going. Often I am enjoying the process so much that I choose to fiddle with one or more of the drawings to refine them, just for the pleasure of it. Sometimes we have to trick ourselves into having fun.

Art Enroute

While enroute—on your daily commute to work, as a passenger in the car on the way to the grocery store, at the airport or on an airplane—make a page of one minute sketches in the small frames format, and one in the open page format. You will be surprised by all the interesting things you notice when you stop to draw what is around you, even in your own neighborhood. When you are done, ask yourself which format most inspires your creativity. Or, perhaps you will enjoy them both, as I do.

Gather Reference Material

These pencil drawings were made in my artistic journal as I sat on the ground on top of a windy hill in Les-Baux-de-Provence, France. I drew quickly —not just one minute, but not much more.

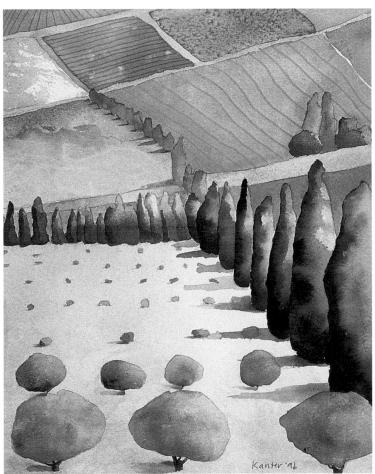

Finished Painting

When I returned to my hotel room later that day, I painted this watercolor in my journal from one of the sketches. Can you see which one I used? I added some dark shadows with a Pigma Micron .35mm pen to the drawing to emphasize the dark shadows under the tall cypress trees. The full-spectrum triad helped me create a beautiful range of bright hues and lively, expressive darks. You can see that there are two more paintings waiting to happen from just a few minutes of sketching

VIEW FROM LES BAUX DE PROVENCE Watercolor on Arches 300-lb. (640gsm) cold-pressed paper 19" x 24" (48cm x 61cm) Collection of George Fabel

Look What Just Three Colors Can Do!

The Color Library

Building a color library is a great way to explore the color possibilities of the full-spectrum triad. I call this a color library because, like a library, it is full of many selections. I like knowing what color options are possible, so that later on I can choose the ones I want to use in a painting—just like choosing books from a library. I don't want to use all the colors possible from a triad in one painting, just as I wouldn't want to take out all the books in the library at one time. But I love knowing all the choices I have. For that reason it is invaluable to build a color library of each of the four triads. See chapter six for a full explanation of all four triads.

Step 1 Mix a large puddle of Winsor Lemon on your palette. Paint a swatch of pure yellow pigment at the top of the triangle.

Step 2 To the pure yellow puddle, add a tiny bit of Winsor Blue to create a warm, yellow-green hue. Paint that color mix next to the pure yellow.

Step 3 Continue adding tiny additional amounts of Winsor Blue until you mix all the way to pure Winsor Blue, recording each mixture. The more gradations you make, the better you are able to explore the unlimited possibilities of triadic painting.

Step 4 Now try making graduated color mixtures between Winsor Lemon and Permanent Rose.

 $\label{thm:complete} \textbf{Step 5} \ \text{Finally, mix Winsor Blue and Permanent Rose to complete the triangle.}$

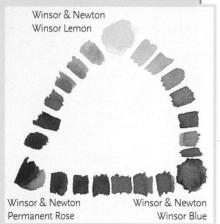

The journal artist's best friend is the full-spectrum triad. With just three colors you can mix an infinite and expressive range of hues. Simplify your palette and enhance color harmony all at the same time. There simply are no *wrong* colors because they all relate to each other. The painting projects in this chapter are a perfect way to get acquainted with the full-spectrum triad.

Four Ways to Mix Triads

To fully appreciate the potential of the full-spectrum triad, you need to know the four results you can obtain by mixing with color triads: pure pigments, brights, shades, and grays and darks. This understanding is key to adding virtuosity to your color mixing vocabulary.

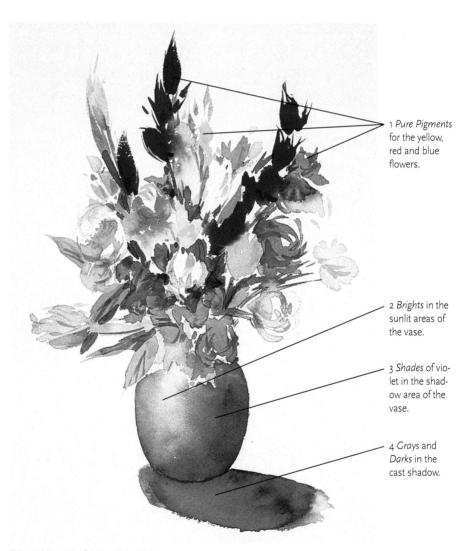

PEONIES AND FIRE ORCHIDS

Karin Felker Harris

Watercolor on Arches 140-lb. (300gsm) cold-pressed paper

10° × 14° (25cm × 36cm)

Winsor Lemon

Permanent Rose

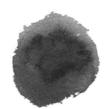

Winsor Blue

Pure Pigments

The first way to use the colors in a triad is to paint with pure pigment directly from the tubes. The full-spectrum triad is made up of the three primary colors. Use them unmixed as red, yellow and blue. You may be surprised to see what optically true primary colors look like. They are the basis of the color wheel and, theoretically, all colors can be mixed from them. Be sure you use the pigments I specify so you can experience the complete sweep and scope of the full-spectrum triad. Dilute with water for lighter colors or use a lot of pigment with just a little water for more intensity.

This orange was created by mixing Winsor Lemon and Permanent Rose.

This violet was created by mixing Winsor Blue (Red Shade) and Permanent Rose.

This green was created by mixing Winsor Lemon and Winsor Blue.

Brights

The second way to use triad pigments is to mix brights. Brights are created by mixing together two of the three pigments in the triad, without the addition of the third. In the full-spectrum triad, these are the secondary and tertiary colors. The exact amount of each pigment in your mixture will determine the color. You can vary the proportions infinitely and, likewise, vary the colors infinitely. You already know how to create brights by building your color library.

I added a tiny bit of Winsor Blue (Red Shade) to the orange to gray the color to this beautiful orangish shade.

I added a tiny bit of Winsor Lemon to the violet mix to gray the color to this lovely eggplant shade.

I added a tiny bit of Permanent Rose to the green to gray the color to this beautiful, shaded green.

Shades

The third way to mix colors with a triad is to create shades. Think of a shady garden in comparison to the same garden in the bright sunshine. You are creating the shaded version of the same color by adding a little bit of the third pigment in the triad. You are really adding the complementary color without having to study a color wheel. This is called *graying* a color, but it doesn't mean you have to get mousy grays. It means you have the power to create gorgeous, rich shades with character and nuance. Again, you can vary the proportions infinitely and, likewise, vary the colors infinitely.

Grays and Darks

The fourth way to mix pigments in a triad is to create grays and darks. Mix all three pigments together, in approximately equal proportions, and you will make a gray or dark black. You can vary the color of the dark by adding more of one pigment than the others. For instance, you can mix a reddish dark or bluish dark. I find these richly colored darks to be much more attractive to the eye than a premixed black. The less water and more pigment you use, the darker your mixture will be. Dilute with water to create light grays.

First Paint, Then Draw

Color Notes

Play with the pigments of the full-spectrum triad by creating a page full of beautiful blends. Look out your window and paint swatches of the colors you see. Free yourself from painting shapes; just let yourself go in an exploration of color possibilities. Spray your paper with water first for a loose, wetin-wet paint application. Look for as many colors as you can and then recreate them in watercolor. If you wish, add pen lines when the paint is dry to describe the view out of your window.

My sketchbook is a jewel box of impressions of the beauty of the world around me. When I want to capture both color and subject quickly, I often use the *first paint*, then draw method. Usually the watercolorist draws first, then adds color to the shapes in the composition. For the sketchbook artist a great way to work in watercolor is to reverse the usual order. Paint first, then draw afterward. The advantage is that I am sure to get some crucial color notes on my page before the light changes, or I run out of time and have to leave. Adding pen lines to describe the subject on top of the color notes completes the picture in a very short amount of time. Use what you know about color mixing with the full-spectrum triad to get just the colors you want to recreate in your atmospheric underpainting.

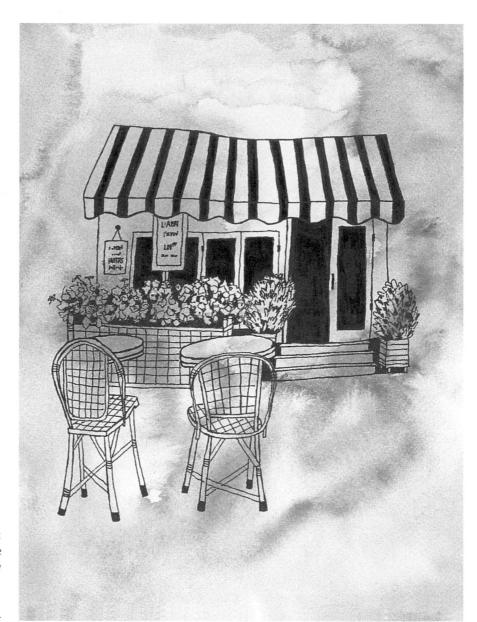

Draw Over Your Colors

This page in my artistic journal was created by first painting, then drawing on a 10" × 8" (25cm × 20cm) piece of watercolor paper. I applied watercolor in a loose fashion, trying to mirror the colors of the Parisian street scene in front of me. I didn't worry about the placement of the colors at all. The aqua blue of the sky, the reds and oranges of the flowers, and the yellow of the awning all appear in my underpainting. I added the drawing after the paint dried, using both fine and ultra fine waterproof felt-tip pens.

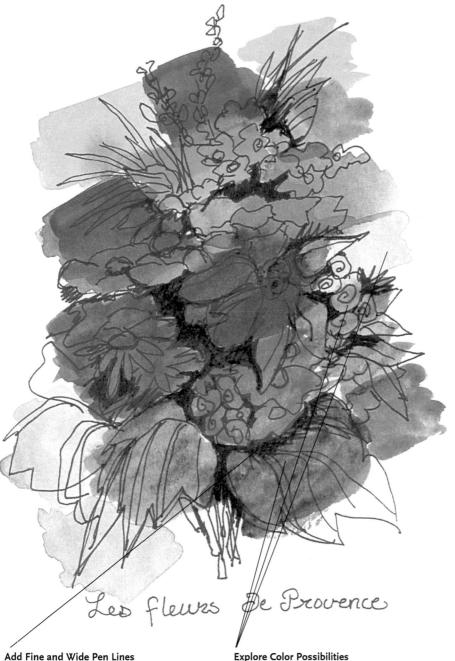

Create beautiful color variations using just three pig-

ments. For example, look at the richness and variety

of the greens.

Add Fine and Wide Pen Lines

Sue used both fine and ultra fine point waterproof felt-tip pens to draw on top of the painted background. Add emphasis with wider pen lines and dark background passages between the flower shapes to bring them into focus. Sue captured both the colors of the market and the shapes of the flowers all within a few moments.

First Paint, Then Draw

This painting of the flower market in Nice, France, uses the full-spectrum triad of Winsor Blue (Red Shade), Winsor Lemon and Permanent Rose. Paint the colors you see all over the page without regard to placement or shape of the subject. Mixing all brights gives the painting a warm friendly feel.

SKETCHBOOK PAINTING Sue Greenbaum Watercolor on Aquabee journal paper 6" × 9" (15cm × 23cm)

Collage the Colors You Love

Do you love the brights? Or do you prefer, as a French friend of mine says, "the colors which have no name"—the shaded, grayed hues? Often you can tell which color palette a person prefers by the clothes they wear. My French friend always dresses in heather-like shades, never bright, primary colors. Another friend always wears brilliant, flowerlike colors-bright fuchsias and reds, brilliant yellow-greens—that are a fine reflection of her vibrant personality. Color choices are a part of the way you see the world, and are reflected in your art. Cut out examples of the colors you are most attracted to from magazines. Collect postcards of artwork, and scraps of fabric with color preferences matching your own. Make a collage in your journal of all you collect. See if you find a pattern to the colors you like. Are they mostly brights? Pure pigments? Shades? Grays and darks? A combination?

Prismatic Painting

Café Art

One of my favorite journaling activities is what I call café art. I complete a page in my journal in the time it takes me to finish sipping a drink. I discreetly write, draw and paint my daily journal entry while enjoying a private moment, away from the demands of others. Treat yourself to a café art date each week and take advantage of a perfect page-aday journal opportunity. Make a prismatic painting of your cup or glass, and learn to mix beautiful rainbow colors with the full-spectrum triad, all at the same time.

Do you remember the first time you looked through a crystal, and brilliant, multicolored fragments of light appeared? When you pass white light through a prism, it disperses into a kaleidoscope of rainbow hues and patterns. This is an example of looking at the ordinary in an extraordinary way. Prismatic painting is my way of bringing the everyday into a different focus and finding beauty in the commonplace.

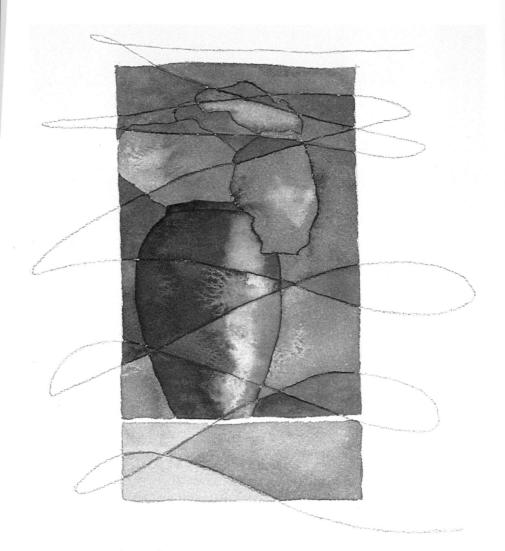

Create Instant Backgrounds

Prismatic painting is an inventive way to resolve what to put in the background—always the hardest thing to compose. The background is composed for you by the intersecting scribbled line shapes. A powerful image emerges from a very simple subject.

Create a Prismatic Painting

MATERIALS

Aquabee sketchbook 9" \times 12" (23cm \times 30cm) or Arches 8" \times 10" (20cm \times 25cm) paper

Full-spectrum triad pigments Winsor Blue (Red Shade), Winsor Lemon, Permanent Rose

No. 4 round 2B pencil Try this project while you are sitting in a café, or at your desk at work.

Take a few moments for creative replenishment. Your subject matter is right in front of you—your drink cup is perfect. Prismatic painting is a natural way to mix an infinite variety of vibrant colors with the full-spectrum triad. The subject of your painting is much more than a cup. It is a reflection of who you are today, mirrored by your unique choice of colors, gestural lines and drawing.

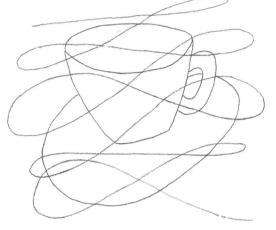

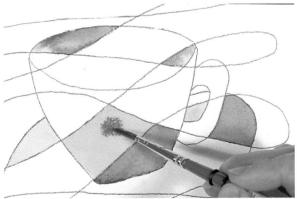

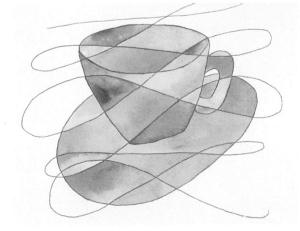

✓ Scribble on Top of Your Cup Drawing

Open your journal to a new page (or pull out a piece of watercolor paper, cut to fit your journal). With a 2B pencil, use your one minute drawing skills to create playful, uncomplicated cup and saucer shapes.

Next, scribble a few swooshes, loops, swirls, figure eights or chevrons all over your drawing. Your energy, mood and spirit will carry through your body and into your hand to create lively line patterns. Let yourself go with the flow of the moment. Prismatic shapes will emerge in front of you as the lines intersect with each other. Keep these intersecting shapes large enough by not adding too many lines.

Orop in Color

In each prismatic shape, paint a different color, created from the three pigments in the full-spectrum triad. Paint by mixing on the paper. With a no. 4 round, underpaint a prismatic section with a diluted glaze of Winsor Lemon. While the paper is still shiny and wet, drop in Permanent Rose.

7 Paint Each Shape Uniquely

Paint each prismatic section separately, creating a kaleidoscope of rainbow colors in each one. Try this wet-in-wet technique for beautiful diffused color mixtures. Be sure to let each section dry before painting the one next to it.

Paint Past the Photo

Photo Art

Go through your albums, and select special photos of fond memories. Perhaps you have a photograph of the house where you grew up, or from a recent vacation. Find several that appeal to your eye and speak to your heart. Or, if you like, make a color copy of the photograph in this book, and follow the steps to make your first painting past the photo. Then try your hand at creating one from your own image bank of photographs. Remember: most of the painting is already done for you. All you have to do is soften the edges a few inches beyond the borders of the print.

Soften the hard edges of a photograph by adding an inch or two of watercolor liveliness at the borders. Use your favorite photographs as the starting point for original watercolor paintings. Add, invent, embellish and extend beyond the four edges of the photo using watercolor. Did the camera cut off the giraffe's head? Paint it in. Do you wish there was a colorful flower garden in front of your house? Take artistic liberties and invent beyond the photo what you would like to see. Transform the frozen reality of a photograph into a living image of your memory and imagination.

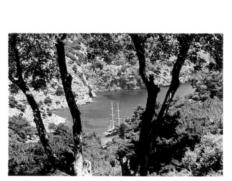

Original Photograph

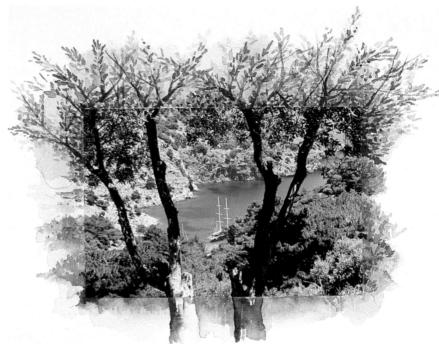

Expand Your Horizons

Look how expansive this scene becomes with the addition of an inch or two of watercolor border. I started with a photograph of the sailboat in Turkey where I taught a painting holiday. I glued the 4" \times 6" (10cm \times 15cm) photograph to a 10" \times 14" (25cm \times 36cm) piece of Arches cold-pressed watercolor paper, and painted past all four edges. The finished photo artwork reflects my fond memories so much better than just the photo alone.

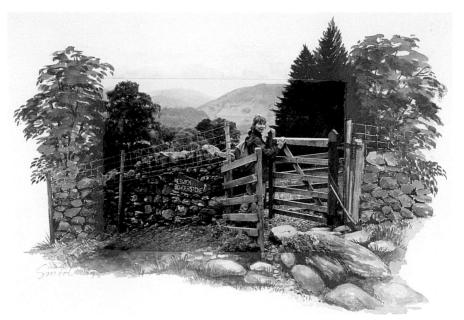

Turn a Photo into a Vignette

Artist Ann Smith added the missing tree shapes, stone wall and path to the edges of the photograph. Her watercolor touches at the borders add so much life to this photograph.

Ann Smith

Photograph and watercolor on Arches 140-lb. (300gsm) cold-pressed watercolor paper $8^{\circ}\times 10^{\circ}$ (20cm \times 26cm)

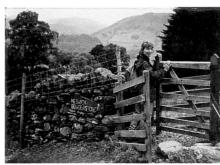

Original Photograph

I used part of two photographs as the basis for this photo painting. I cut out sections from two photographs, matched them at the edges, and glued them onto a piece of watercolor paper. I painted in a bit more of the figures cut off in the photos. That's me with the black visor hat, listening intently to instructions before playing my first-ever game of bocce ball.

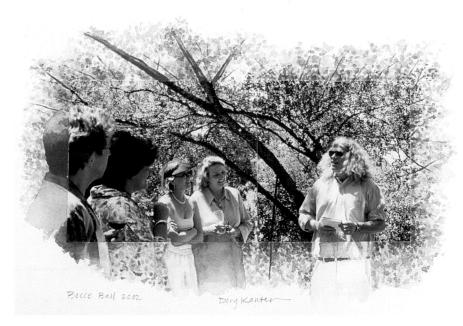

Original Photographs

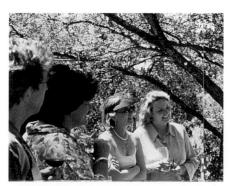

Paint Past the Photo

MATERIALS

Arches 10" x 14" (25cm x 36cm) 140-lb. (300gsm) cold-pressed paper Full-spectrum triad pigments Winsor Blue (Red Shade), Winsor Lemon , Permanent Rose

Glue

No. 4 round

Photograph or color copy of a photograph

Scissors

2B pencil

This is a painting of my front gate. Can you see where the photo ends and the painting begins? I loved being able to cut the power line out of the photo in the sky above the trellis. What was a rather pedestrian photograph is now a much more romantic depiction of my old fashioned front yard with the clematis blossoms in their full glory.

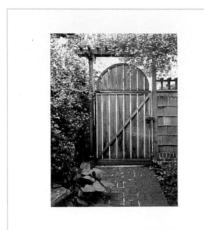

Glue Photo to Watercolor Paper
Glue your photograph to the middle
of a piece of Arches cold-pressed watercolor paper, or a page in your artistic journal.
Crop the photograph as you wish. If you
don't want to cut or glue your photograph,
use a color copy.

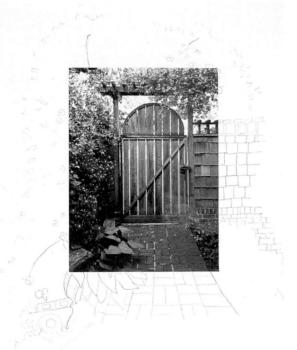

7 Draw With a Pencil

With a 2B pencil, lightly draw in a continuation of the photograph to give you a guideline for painting. It helps to draw in the architecture of buildings or, in this case, the fence, to give your finished painting a convincing look.

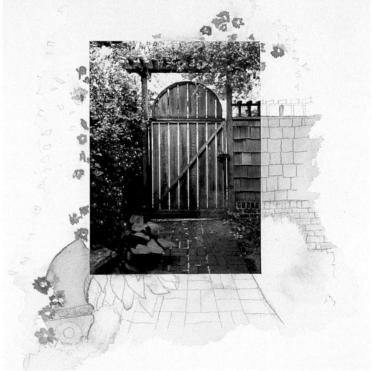

Underpaint at Each Edge

With a no. 4 round, underpaint a pale version of the colors you see at each of the four edges. This will define the outside edges of your painting and give you a color plan to work from. Use the full-spectrum triad for a complete range of color possibilities and perfect color matching.

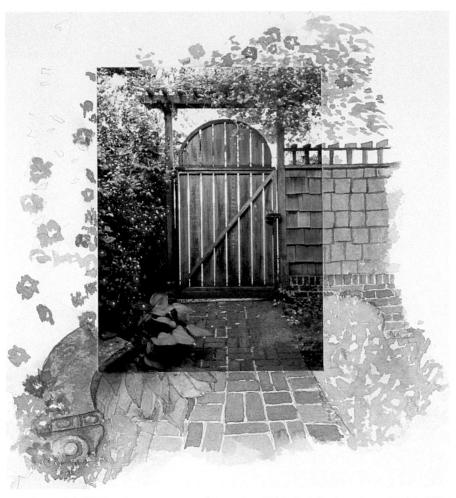

Refer to Your Color Library
Match the shapes and colors at the edges by using all four methods of mixing with triads: pure pigment, brights, shades, and grays and darks. Maintain a loose, vignette quality to your painting at the edges—it will breathe life into the photo-

graphic image.

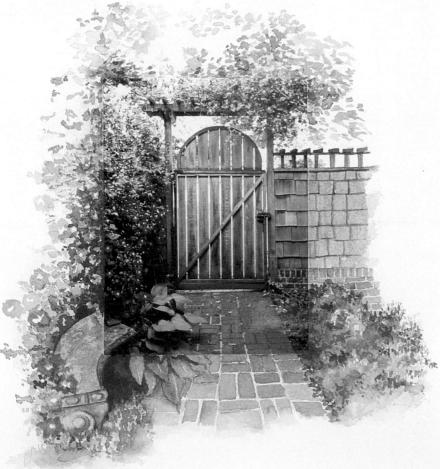

Snap It Into Focus With the Darks
This last step really makes the painting sing. Add the darks that you see in the photograph, especially at the edges.
Match both the light and the dark colors from the photograph into your painting.
This is the way to make sure the transition from the photograph to the painting is smooth. Often it is the addition of the very darkest colors that make the painting snap to life.

Opportunities for Everyday Creative Moments

Very often I am sitting at dinner and take out my notebook. I get very inspired when I eat, for some reason.

~ Claes Oldenburg.

believe that when it comes to art, quantity equals quality. The more art you do, the better you get. The sheer quantity of creation leads to an enhanced quality of self-expression. The more images you create, the more fluid your imagination becomes. That's where keeping an artistic journal comes in. Fill your pages with observations every day—the more the better. This chapter is designed to help you discover creative moments in your day that you may not have realized were there. Imaginative opportunities lie camouflaged in our everyday lives. The projects in this chapter will help you create art out of the unexpected, and find inspiration for paintings from surprising sources.

RIVER REFLECTIONS
Watercolor on Arches 140-lb. (300gsm) cold-pressed paper
26" × 20" (66cm × 51cm)
Collection of Jean Avel

Creative Doodling

Life is full of situations where it is easy to feel creatively trapped. Do you have a lengthy meeting to attend, or anticipate a long wait at the airport? Commit an act of creativity. These are perfect moments for creative doodling. Don't we all love to doodle? Let your pencil do what it wants, without censoring—even though your concentration might be centered elsewhere. I love to doodle while talking on the telephone. Creative ideas flow when you are not trying so hard to be ingenious. Journal opportunities will abound.

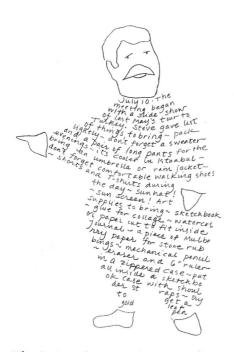

Why Can't Business Meetings Be Fun?

Take meeting notes by adding the figure to a quickly sketched face. This mustachioed caricature started as a doodle of a gentleman's face as he was speaking at a meeting I attended. My handwritten notes of his comments form the simple body shape.

The Caricature Doodle

Next time you're at a lecture, convention or meeting make quick cartoon caricatures of the participant's faces. Pick out one distinguishing feature—earlobes with dangly earrings, a thick head of curly hair, arching eyebrows, a pointy chin—and draw that first. Next, add the outline of the jaw and chin shape. Add a squiggly line for the hair. You can scribble just a pair of glasses on a circle, or a big mustache on an oval. This is not a drawing, not a sketch—it's a doodle! Jot down the name of your subject by your caricature for an artful way of remembering names and faces.

Frame Your Day With a Doodle Border

Some days all I want to do is create a border design in my artistic journal. Maybe I'll return to it later on, and fill in the empty space in the middle, or maybe not. I find it energizing to make spontaneous, unplanned designs. First, make doodles, in pencil or pen, all around the four edges of a new page in your journal. Play with simple shapes and repeating patterns in a free-form kind of way. There is no right or wrong. I don't try to draw anything from reality—just squiggles, lines, dots and shapes. Doodle while on the telephone, at a meeting, listening to music or even watching TV. With your conscious mind occupied, you liberate your unconscious to reveal itself.

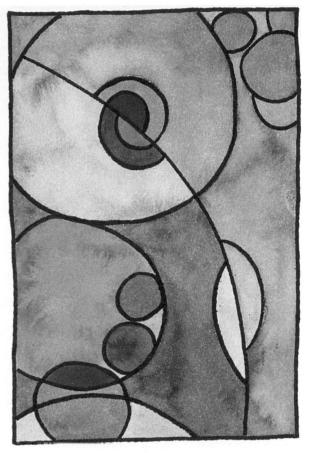

Discover Personal Symbols in Your Doodles

The design for this watercolor painting came directly out of the doodle border. Take note of the shapes or marks that appear in your doodles. They are your personal hieroglyphics. I noticed that both circles and squares, and parts of them, turned up over and over again in my doodle. I enlarged two elements of my doodle border into this composition of overlapping spheres. Aristotle said that "the soul never thinks without a picture." Bring meaning to your work by awakening to this rich source of personal imagery.

The Creative Matrix

Growing up, one of my favorite summer activities was catching fireflies at night. Those few seconds holding the glowing insect in my loosely cupped hands, examining it for just a moment before letting it go free, delighted me. The cre-

ative matrix permits a similar kind of momentary examination of fleeting but precious moments. Celebrate a day, week, weekend, workshop, travel adventure or any other life experience. Visual and written note taking raises

the ordinary to the extraordinary. The creative matrix is a private diary that helps you hold onto meaningful everyday moments and illuminate personal memories.

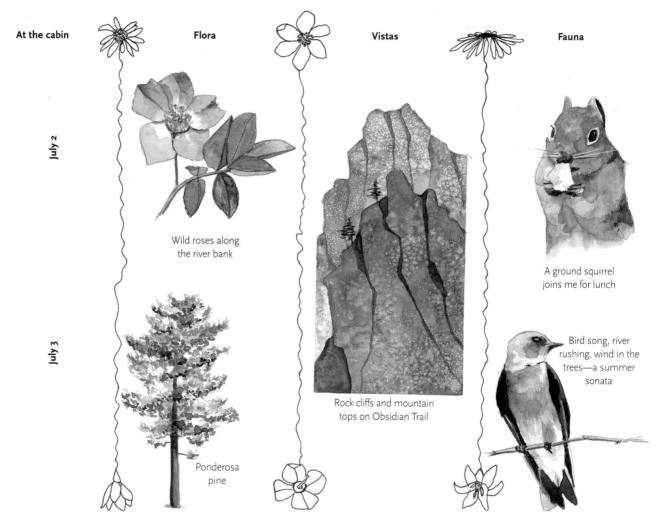

Weekend Matrix

This is a creative matrix I made while at our vacation cabin in central Oregon. There are so many things I love about being there. The matrix framework helped me to focus on just three of these—the flora, fauna and mountain vistas. In trying to decide upon my matrix categories, I realized that these were the subjects I was most interested in during a short two-day visit. Creative limits encourage self-discovery. The framework of the matrix keeps me from being overwhelmed by the possibilities and helps me focus my attention on the slice of life truly important to me right now.

Workshop Matrix

I made this creative matrix while I was attending a writing workshop on the Pacific coast. I used two facing pages of my journal, which gave me more room to draw, paint and make written notations. This matrix is a valued remembrance of a wonderful weekend staying with good friends and being inspired by writer Kim Stafford. I kept notes of this delightful weekend within the framework of my artistic journal matrix. The first creative choice is deciding which categories to illuminate. I'm glad I preserved some of the essence of my experience by focusing on Kim's quotes, highlights, land and sea, and small treasures. After I decided on the categories, the matrix gave me a structure for reflection, a creative way to reveal delicious morsels of meaningful memories.

Make a Creative Matrix This Weekend

What do you love about each season? How do you mark the turning from summer to autumn? Winter to spring? Use the creative matrix as a way to chronicle the changes you observe. Pick several categories or qualities about each season to investigate. Another approach is to make four identical seasonal matrices maintaining the same categories for each one for an ongoing investigation of the progression of the yearly cycle. Colors, foliage and birds are examples of facets to explore. Leave room in your journal for the four matrices so one can flow right after the other. Sometimes, we overlook the rich creative opportunities-such as the seasons—that are all around us.

Saturday Sunday Natural Wonders

Copy This Matrix Template Into Your Journal

Use this design as a template for your first weekend matrix. Enlarge it to the size of one of your journal pages. Photocopy or trace it into your sketchbook. This is an invitation to make a hand-drawn, handwritten illuminated manuscript of your weekend. Interpret the categories as broadly as you wish. Draw, write, collage, doodle, make lists—anything goes. Don't stick to strict grid boundaries, I never do. Pick a weekend with nothing special going on. The matrix is about moments, not the momentous. You'll find there is a lot more to remember than you would have guessed.

Matrix Categories to Glet You Started

This list contains some areas of observation that you might find useful in building your own matrix. This is just a beginning: There are as many possible categories as there are facets to your life. In other words, they are endless. The important thing is to create categories for your matrix that encourage you to focus in on slender, but precious, aspects of your experience. Each matrix you make will be different. Through each one, by committing to a few choices out of the myriad of possibilities, you intensify your powers of observation. Not only is this true of making a matrix, but it is true of life itself. Art imitates life, once again!

Senses

Sights
Scents
Sounds
Tastes
Touch/textures

Nature

Flora and fauna
Feathers and beaks
Land and sea
Waves and clouds
Sun and rain
Sticks and stones
Light and shadow
Natural wonders

Travel

Getting ready Getting there Being there Going home Local color Vistas and views Bathrooms everywhere Cafés of note Joys and woes New friendships Hotels rooms Cameos and brief encounters Cultural differences Les faux pas Architectural details and decorative motifs Trains, planes, automobiles and boats: the details On the go and slowing down Shopping memories Crossing boundaries Street signs and lamp posts Packing tips Local cuisine and personal picnics My own maps In the market today What I miss about home

Books I took and books I read

People and Family

Friends, yesterday and today
Making connections
Building bridges
Hurdles and agonies
Quotable quotes
Truth and lies
Love and admiration
Still growing
New best friends

Just About Me

Simple pleasures and little luxuries Choices and challenges Foolish fun and folly Life's little lessons Awakenings and inspiration Rest and recreation Random thoughts Dreams and imagination Moments of grace or virtue Fun and laughter If I could do it all over again... Advice taken and not taken Being alone Highlights of the day Memorable moments Books to read Moments of celebration

Emotions

Everyday magic
Spontaneity
Reactions
Passions
Clarity or confusion
Surprises and questions
Worries and scary
moments

Windowpane Painting

Life is a Verb

Discover a symbol of yourself by looking through magazines for illustrations of people in motion-dancing, flying, jumping, digging, falling, sleeping, swimming and so on. Don't overlook illustrations or photographs of animals in action. Animals are powerful symbols of the self. Think about your life in terms of a characteristic movement or pursuit. What action suggests your life right now? What verb describes your current energy and essence? Borrow an image from a book or magazine illustration that speaks to you. As Pablo Picasso said, "Good artists copy, great artists steal." Rework your borrowed image into a simple drawing representing your present state of mind. The key is simplicity. Use this image to make a symbolic self-portrait windowpane painting.

Many of these journal projects are designed to nudge you, the artist, into framing or reframing what you see. Windowpane painting asks the artist to imagine an uncomplicated image, bordered by the architecture of four windowpane sections. Each windowpane alters the image slightly, tinting it with different textures and hues. The simpler the subject, the stronger the windowpane painting—a perfect combination for sketchbook art. I love to watch how one image comes together like four separately hand-painted tiles.

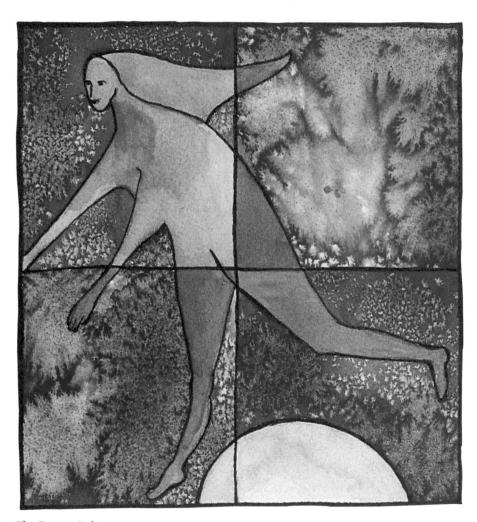

The Escape Artist

This windowpane painting came from a tiny sketch made while my husband and I were driving in rural France. I saw a billboard with a childlike figure and did a quick one minute sketch while on the road. Later on, I designed a figure of my own and had her fly in the sky over a full moon. I call this painting *The Escape Artist*. It is a favorite private symbol. With sketchbook and pencil in hand, I can escape to a personal place of reverie, no matter where I am. The background areas were sprinkled with salt while the paint was still wet to create the star patterns.

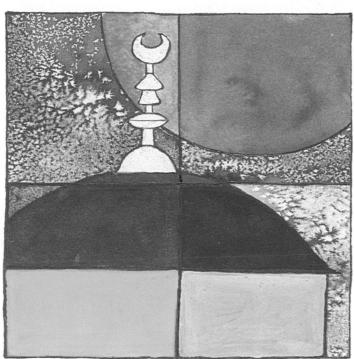

Istanbul Sunrise

Turkish Colors Grace a Painting

I painted this windowpane painting in my Komtrak binder journal, using watercolor paper that can be inserted into the binding. While in Turkey, I admired the luminous effect of the remarkable Iznik tile work facing the interior and exterior of many Ottoman buildings. I borrowed the colors characteristic of Iznik tile work for this painting of a mosque at sunrise—rich red, orange, turquoise, blue and green. I finished the painting by adding metallic gold accents from my Krylon gold leaf pen. All the elements of this design, including the crossed lines of the *windowpanes*, were outlined with black felt-tip pen.

Don't Just Shop for Dinner

MATERIALS

Arches 140-lb. (300gsm) cold-pressed paper

Drafting tape

Full-spectrum triad pigments Permanent Rose, Winsor Blue (Red Shade), Winsor Lemon

Pencil

Pigma Micron .50mm black pen or waterproof felt-tip pen

No. 4 round

Table salt

Use the hidden opportunity of your routine grocery shopping to beckon a creative moment into your day. Pick out one beautiful piece of fruit or vegetable to use as a subject for a windowpane painting. Who knows? This could be the beginning of a charming kitchen series.

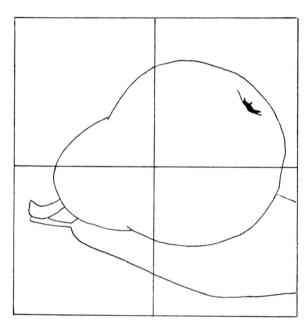

1 Trace the Design

Lenlarge this drawing of a pear on a photocopier and trace it onto a piece of 140-lb. (300gsm) cold-pressed watercolor paper sized to fit inside your journal. An easy way to trace is to place the photocopy behind your piece of watercolor paper and secure them to a bright window. You will be able to see the photocopy from behind the watercolor paper. Be sure to draw the crossed lines creating the four squares. Tape the edges with drafting tape to make painting the borders of the design easier.

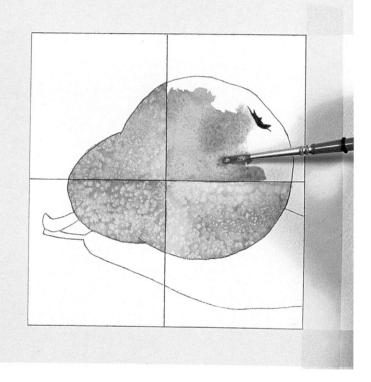

Paint the Pear in Sections

Using the full-spectrum triad, mix different colors for each of the four pear sections and paint each one. While the paint is still shiny wet, sprinkle it with salt to create a textured, naturalistic pear surface. Be sure to let each section dry before going onto the next one.

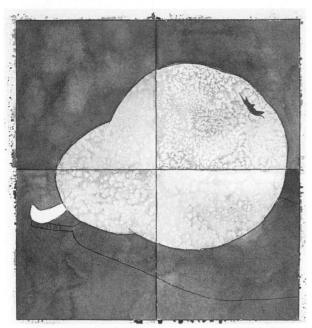

Paint the Four Background Sections
Using the full-spectrum triad, mix
four different purple colors for each of the
four background shapes. Your background
painting will be untextured, while the pear
shapes are by contrast textured with salt.
This is the opposite of my examples, The
Escape Artist and Istanbul Sunrise (see
pages 48 and 49). There are many ways
to go with windowpane painting.

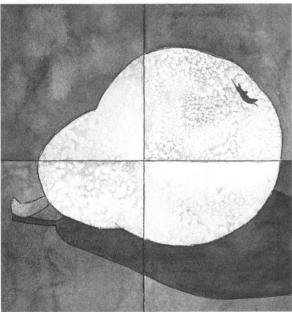

Paint the Stem
Paint the stem using a mixture of dark brown paint. When dry, darken the shadow areas in the two bottom sections. You may want to review the section on color mixing grays and darks with triads on page 31.

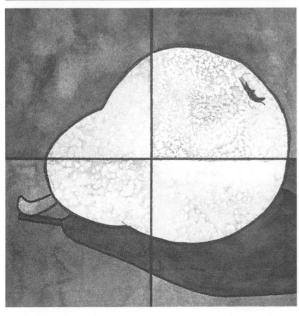

Once you are sure everything is dry, remove the drafting tape. Go over all the lines of the pear, shadow, windowpanes and outside edges with waterproof felt-tip pen or black ink pen.

Room With a View

I love to look at landscapes framed by a window. When I lived in China, one of my special pleasures was riding on trains and viewing the passing landscape enclosed by the window and the ubiquitous white embroidered curtains. Hotel rooms, restaurants, portholes, my own home, friend's homes, they all provide unexpected opportunities for the landscape painter. For a new twist on the theme, draw everything inside the room with pen, adding watercolor only to the scenery outside the window. This fresh technique gives the viewer a sense of being in the room with the artist, while letting the landscape outside the window take center stage.

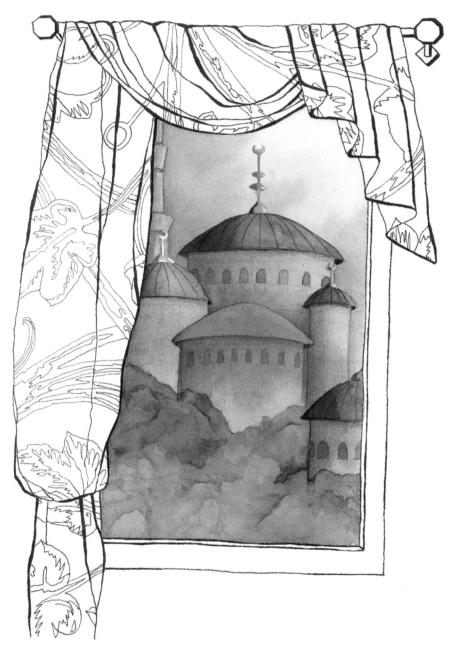

Ink the Interior, Paint the Exterior

I love to make room-with-a-view paintings of each of my hotel rooms when I'm traveling. I am always intrigued with the view, no matter what it is. In this case, my Istanbul hotel room offered an architectural and atmospheric treasure. I used pen to draw in the outlines of the window and the elaborate drapery. I went over some of the pen lines to emphasize the folds and edges of the fabric. Before painting the towers and domes of the Blue Mosque, I underpainted the entire area of the exterior landscape with soft pastel colors suggesting the golden glow of the rising sun. I wet the whole window area first with clean water, then dropped diluted mixtures of the full-spectrum triad onto the damp paper. After this soft underpainting dried, I completed the painting by adding architectural details of the mosque and the trees in the foreground.

Capture Simplicity and Sophistication

MATERIALS

Arches 140-lb. (300gsm) cold-pressed paper

Full-spectrum triad pigments Permanent Rose, Winsor Blue (Red Shade), Winsor Lemon

No. 2 round

Pencil

Pigma Micron .50mm black pen or waterproof felt-tip pen I spent a peaceful weekend at a friend's home in the country. The lovely view out the window summed up my feelings for their warm and cheerful home. The combination of ink for the window and watercolor for the landscape outside, helped contrast the sophisticated interior of the room with the rustic landscape. I painted the scene outside the window with a childlike primitive quality to convey the simple pleasures of their country life.

Draw the Window and Curtains

On a piece of watercolor paper sized to fit your sketchbook, draw the window ledge, window frame, curtains and other features of the room using a black felt-tip pen. Draw the scene outside the window lightly in pencil. The great part is that your composition is already framed for you by the boundaries of the window.

Bring Color to the Landscape

With the full-spectrum triad, paint the landscape framed by your inked window. I made a rich variety of greens using my method for mixing brights and shades with the full-spectrum triad (see pages 30 and 31).

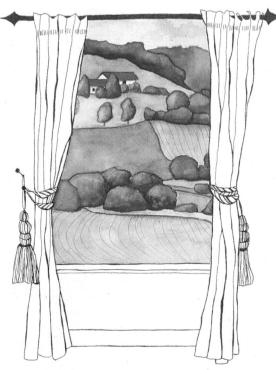

Add Details

Add a few details and the painting is omplete.

Travel Art Tips

The Collection

One of the joys of travel is becoming aware of the differences between cultures. Gather a group of items spiced with the local color—objects delightfully different from home or special in some singularly foreign way. The subjects of your journal collections are direct reflections of what you uniquely observe and love about the country, state or city you visit.

I think it's obvious—I love to keep artistic journals when I travel. Café art, the creative matrix, watercolor mosaics, one minute drawings—so many of the projects in this book were born while pursuing my practice of journaling when I travel. My children keep travel journals, too. They especially love suggestions for new, freeing formats. It's also fun to collaborate on journal pages with your travel partners. But, perhaps my favorite travel moments are those quiet, private ones, sitting in a shady café, drawing and painting. Here are a couple of my favorites for you to try on your next journey.

Les Cornets de Glaces Violette . Miel-Lavande Cavande · Pomme Verte Comate-Basilic . Olives de Nice

A Collection of the Ice Creams of France

I never could have predicted the fabulous flavors of ice cream in southern France. I realized on my first day in Nice that I had to make an exhaustive, personal study of the subject. My husband was happy to offer his assistance as we sampled an array of ice-cream cones during my journal "research." First, I put empty ice cream cone paintings on my page, then filled in the names of the flavors and colors of the ice-cream scoops as I went along. It took me two weeks to finish this travel journal page. I patiently waited for the most amazing flavors to appear before including them in my collection. Here are the flavors I discovered: Violet, Honey-Lavender, Lavender, Green Apple, Tomato-Basil, Olives of Nice.

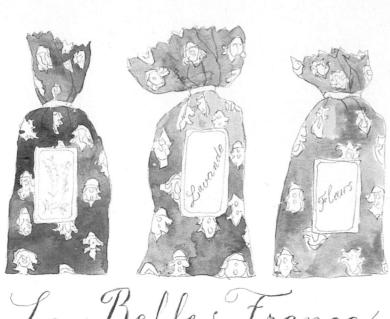

La Belle France

September 2000

Sachets Adorn My Title Page

This is the frontispiece, or title page, of one of my travel journals. I always begin with a page indicating the destination and the date. On the day we arrived, I fell in love with these little lavender sachets sewn with colorful provençal fabrics. This page is a collection, first drawn in pencil, then painted in watercolor. A simple idea can create a beautiful travel memory page.

Observation Icons

Isolate small aspects of your travel experience into delicious visual treats. Observation icons are painted symbols of the beauty of the natural world, edged with silver or gold, displayed on your journal page with raised mounting tabs. One approach is to choose a single theme for a group of icons on a page. Another is to devote a whole page to one special image. We all seem to appreciate the natural world more when we travel, when we see with refreshed eyes. Perhaps it is because we take the time to really look that makes the difference.

The Sea

Bodrum May 12

Gümüsklük May 13

Knidos May 14

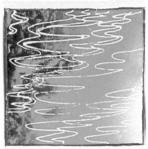

Bozykkale May 15

EKincik May 16

Agliman May 17

Six Views of the Sea

I made this page of observation icons while sailing on the Aegean off the southern coast of Turkey. The sea was so beautiful—tinged and altered by the time of day, the light, wave patterns and weather. I wanted to record daily views of this fascinating phenomenon. Each day for six days, I painted one of the watercolor paper squares with the colors, textures and patterns I saw in the sea. I colored the edges of each sea icon with my Krylon gold leaf pen. I attached each icon to my journal page with four double stick mounting tabs, one on each corner. Each sea image is labeled with the place and the date.

Create an Observation Icon

MATERIALS

Arches 140-lb. (300gsm) cold-pressed paper cut into small squares
Full-spectrum triad pigments Permanent Rose, Winsor Blue (Red Shade), Winsor Lemon

Double stick mounting tabs, available at most office and craft stores

Gold Krylon pen

No. 4 round or medium Niji waterbrush Pencil and pens These geraniums were one of many that graced the courtyard of my hotel in Bodrum, Turkey. They are the perfect example to demonstrate how to make an observation icon. I love to use a medium sized Niji waterbrush when I travel. It holds water inside the handle. All you do is squeeze and clean water comes out.

Create a Small Painting
Cut a small piece of watercolor paper,
and paint the pot of geraniums. Use the
full-spectrum triad, which is perfect for the
bright, primary colors of this vibrant environment.

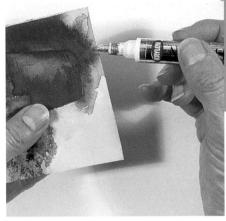

Gold Leaf the Edges
Color the edges of the finished painting with a Krylon gold leaf pen, creating the effect of a gold frame. Be sure to go over the edges two times with the gold pen to ensure an even metallic coating.

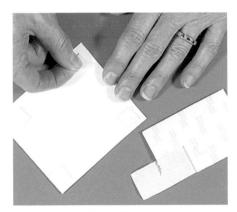

Press on Mounting Tabs

When the gold ink is dry, attach four double stick mounting tabs to each corner of the back of your painted observation icon and place it in the center of your sketchbook page.

Flower Pot at Su Otel Bodrum Turkey May 12 · 2 001

Place Your Creation
Add a title and caption, including the place
and date. This example
shows just one observation icon. The painted
image is highlighted with
the raised mounting and
the gold leaf edging.

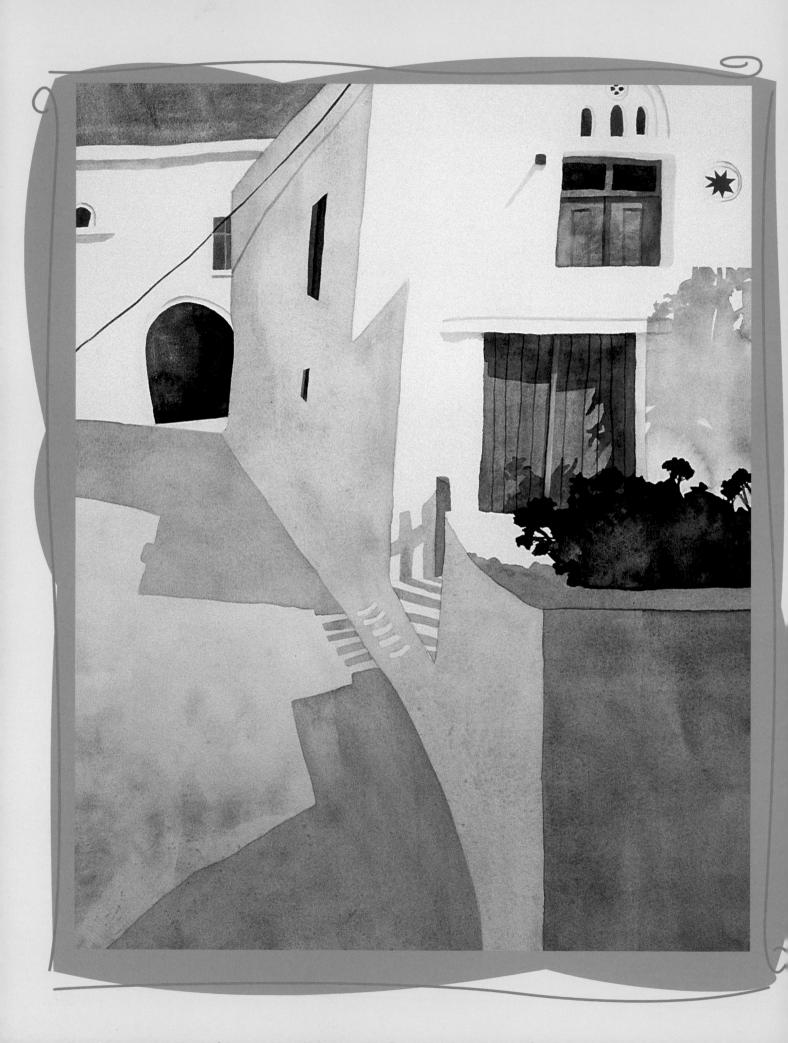

Putting It All Into Perspective

Painting is just another way of keeping a diary.

~ Pablo Picasso

Vour perspective is what makes you, you. You can bring more of yourself to your paintings and drawings with the art of perspective.

The traditional way to use perspective is to create the illusion of depth and dimension on a flat surface. Another way to use perspective is what I like to call creative framing. Creative framing is using an out-of-the ordinary vantage point to translate your inner impressions. The creative exercises in this chapter will show you how to use both of these approaches. Get ready

for some new perspectives on perspective!

A comfortable understanding of perspective drawing—the traditional method—allows the viewer to see a landscape or interior from the artist's point of view. In the watercolor painting on the opposite page, I made use of one-point perspective to beckon the viewer to cross the threshold and step into this Greek island lane. As you look at this watercolor, it is as if you are standing in my shoes while I was creating it. Step a little to the left or right and you would see a different view.

Now, take a look at the sketchbook drawing on this page. It is a mixture of perspectives and conflicting planes. I drew it as if seeing the buildings from many different vantage points all at once. I wanted to suggest the quality of a hand-built environment—houses all cobbled together, no square corners or right angles in sight. Manipulating traditional ideas of perspective produces a very personal and playful vision of this same Greek village.

Keeping an artistic journal as a daily reference point helps me put my life into perspective, too. Some days, life is a jumble. As I sit down with my journal, I wonder what to capture. Shall I concentrate on just one narrow slice of my day? Or, embrace the larger constellation of my life? I use my artistic journal to reflect on my surroundings and sensations. Journaling is a wonderful way to discover your point of view and find a natural focus. The act of keeping art in my everyday life helps me truly acknowledge the present, appreciate the past and anticipate the future.

BLUE AND WHITE, SANTORINI Watercolor on Arches 140-lb. (300gsm) cold-pressed paper 26° × 20° (66cm × 51cm) Collection of Jan Stewart and Gordon Allen

Bird's-Eye View

One of my favorite art escapes is imagining a landscape from an aerial perspective. There is something dreamlike about visualizing flying above a garden and seeing it from a bird's-eye view. I love the play of shadow patterns against the blueprint of strong garden elements. Painting from a bird's-eye view puts fundamentals of one-point perspective effortlessly into your hands.

You will quite naturally discover rules of one-point perspective while doing this creative exercise.

I learned to use perspective only when I felt the need to show depth more convincingly in my paintings. So, I had a quick consultation with my friend, Bill, an architect. He simplified the basics for me quickly over coffee, drawing on the back of an envelope. Off to the studio I went to experiment. My advice is to avoid getting hung up on the rules and mathematics. Instead, dive into this exercise and learn to play with perspective—don't stress about it.

Escape from the ordinary by envisioning a garden in your mind's eye from the sky.

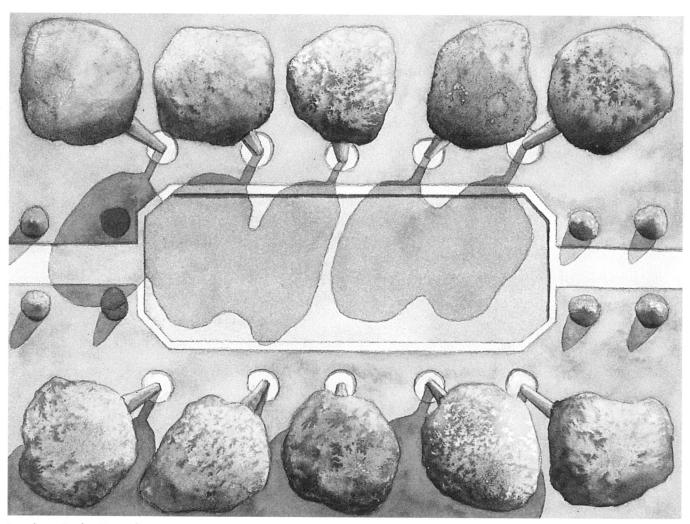

Imagine a Garden From Above

There are many drawings in my journal of imaginary gardens as seen from above. My own garden at home is a tiny, shady courtyard. Perhaps that's why I love to imagine landscapes with big expansive lawns, pools, tall trees and blazing sunlight. This watercolor painting came from one of these imagined garden sketches. One-point perspective helped me bring dimension and depth to the painting, inviting the viewer to look down into the garden from a point directly above. Seeing the garden from above allows me to highlight the shadow patterns of the trees and bushes, as well as show a footprint of the whole garden plan. I included a pathway at the right and left to suggest that the garden continues into the distance.

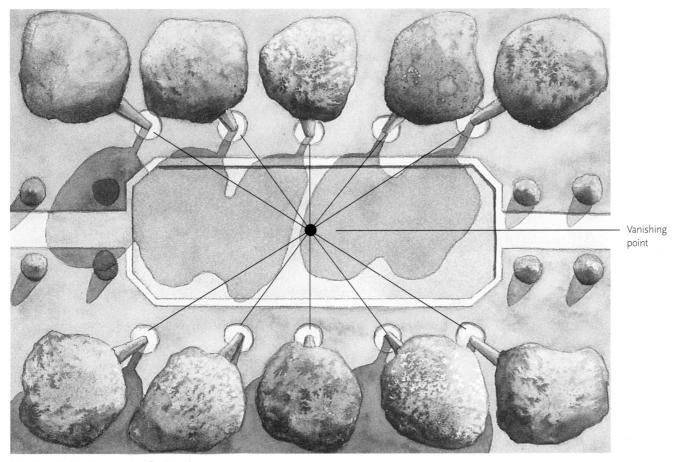

Use One-Point Perspective for Depth

This invented landscape allowed me to decide exactly where the bird in my bird's-eye view is suspended over the garden. I decided that the bird is flying directly above the center of the garden. Think of a bird flying with a camera and taking a picture while hovering directly above the middle of the pool. That point is the vanishing point. That's the point of view of this painting and all the lines of the tree trunks refer to that point. That is one-point perspective in a nutshell (or eggshell). All you have to do is slant all the tree trunks so that they line up pointing to the vanishing point. Use a straightedge to connect the dots of the tree trunks to the vanishing point. That's all there is to figuring out the angles of the trees.

* Page-A-Day IDea

MATERIALS

Arches 140-lb. (300gsm) cold-pressed paper

Drafting tape

Full-spectrum triad pigments Permanent Rose, Winsor Blue (Red Shade), Winsor Lemon

Nos. 2 and 4 rounds

Pencil

Salt

Straightedge or ruler

Paint Your Home From a Bird's-Eye View

Pretend you are a bird flying above your own home and garden. All you can see is the design of the garden, not all the branches and leaves and certainly not any garden debris. Concentrate on the overall blueprint, not the details. You may want to invent what you would like your garden to look like. This can be a wonderful wintertime journal activity. If you don't have a garden where you live, invent one. In fact, don't stop there, invent a house or cottage to put beside it. Use one-point perspective to create a sense of depth as you look deep into your garden space.

Follow along with me as I paint an invented garden landscape as seen from a bird's-eye view. I discovered this style of painting several years ago when I stood at the top of a tall Venetian tower and looked at the garden directly below. I loved seeing the design the trees and their shadow patterns made from this unusual vantage point.

✓ Draw the Garden Elements

Lenlarge my painting on a photocopier and trace it onto a piece of watercolor paper. (Or create your own bird's-eye design.) An easy way to trace is to place your drawing or photocopy behind your piece of watercolor paper and set them up against a bright windowpane. You will be able to see the drawing right through the 140-lb. (300gsm) watercolor paper. Tape the edges of the drawing with drafting tape. Be sure to draw in the shadow patterns made by the trees. Notice that all the shadows of the trees are parallel with one another. This is always true of shadows emanating from the sun.

Paint the Grass Areas

Mix an ample amount of green for the grass by combining Winsor Lemon with Winsor Blue. With a no. 4 round, paint all the lawn areas an even yellow-green. Continue with the no. 4 round to paint the pool an evenly applied blue shade, using Winsor Blue with a touch of Permanent Rose.

Paint the Trees and Bushes

Use the no. 4 round to paint the foliage of the trees a light yellow-green mixed with predominantly Winsor Lemon and a small touch of Winsor Blue for the sunlit areas, and dark green for the shadow side. I mixed a dark green hue by first creating a bright green of Winsor Blue and Winsor Lemon. To that mixture I added a small bit of Permanent Rose to gray the color to a deep, dark green. While the paint is still shiny wet, drop in salt for a textured appearance (see page 83). It helps to draw an arrow or symbol on the taped edge to remind you of the direction of the sun.

Paint the Pathways and Tree Trunks
With a no. 2 round, paint the pathways a light yellow-tan made by mixing Winsor Lemon with a bit of Permanent Rose. Paint the trunks of the trees a brown shade using the no. 2 round, keeping the sunlit side lighter, and darkening the shadow side. My trick for mixing rich browns is to make a bright orange with approximately equal amounts of Winsor Lemon and Permanent Rose. Then add little bits of Winsor Blue to gray it to just the right brown color.

Paint the Shadows

The trees and bushes cast deep shadows from the sunlight. With the no. 2 round, darken the lawn, pool and pathways in the shadow areas. Use a more concentrated mixture of the same pool blue you used originally. Mix the grass shadow color from Winsor Blue and Winsor Lemon. Remember to pay attention to the angle of your shadows; they should be parallel to one another to replicate how shadows from the sun appear. Remove the tape and take a visual walk in your imagined landscape.

Piazza Perspective

Invite some friends or family members to Italy! Along the way, you will discover two-point perspective as you paint your loved ones into a Renaissance town square.

Perspective drawing teases the eye into seeing and believing an illusion of depth. The best way to learn perspective drawing is by having some fun with it. With this creative exercise you will gain a comfortable intuitive understanding of how two-point perspective works, all by putting your hands to work building a piazza. Come along and I'll show you the tricks and techniques you'll need for the construction of this painting.

I know it's easy to get stumped and confused by the rules of perspective drawing. Trust me on this one—your painting will be dramatic and realistic after completing this creative itinerary.

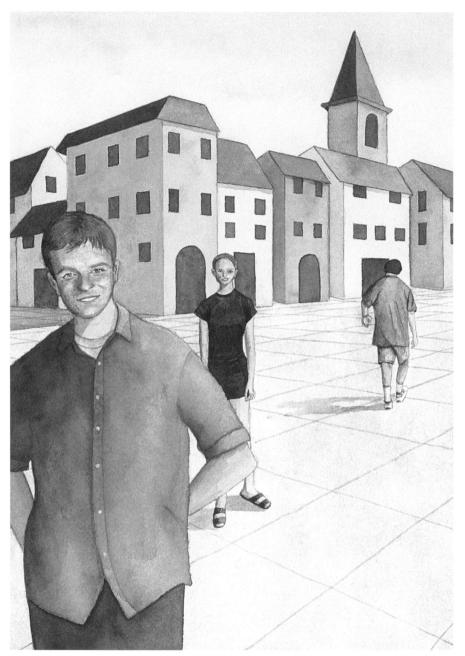

Use Two Eyes to Create Three Dimensions

Here is a trick about perspective drawing. Figures of the same height, on the same plane, all have their eyes at the same level, no matter how close or far away they are. This is a useful thing for the artist to know.

Let's look at our Italian piazza. I drew all three figures as if they were all basically the same height. The eye level, my vantage point, is the reference point for everything in the drawing. My son, standing closest to me, is the young man at the left. (I can almost hear him say, "Hurry up and finish drawing, Mom!") My daughter, in the middle, is standing further back. My husband, at the right, is walking even further back in the piazza.

Notice that all eyes are at the same horizontal level—the eye level—even though the figures are in different places on the town square. That's the interesting thing about this particular perspective situation. Keep the eye levels of the figures constant (assuming everyone is about the same height) and the feet will end up in the right spot. If you want to put a shorter person or child in the picture, you simply have to lower the eye level a little bit below the standard reference point.

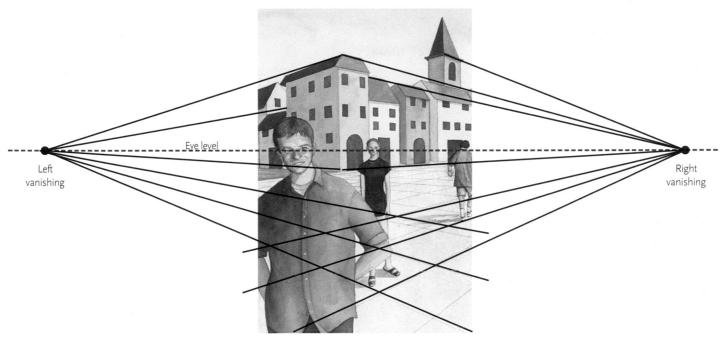

Vanishing Points Create Perspective

Take a look at the rooflines and tops and bottoms of the windows. They all slope downwards, meeting at two vanishing points, one at the right and one at the left. Now look at the base of the buildings. They slope upwards, meeting at the same two vanishing points. Above the eye level, lines slope down; below the eye level, lines slope up. Two-point perspective comes into play when you look at a building from an angle. Basically, when you can see two sides of a building, then you'll have two vanishing points, which means two-point perspective. Simple enough! To simplify further, note that all the vertical lines of our buildings stay parallel to each other.

Let's look at the paving stones of the piazza. See how the lines of the pavement also meet at the two vanishing points. Use perspective to make a tile floor or paving blocks look realistic.

Paint With Perspective

MATERIALS

Arches 140-lb. (300gsm) cold-pressed paper cut into small squares

Drafting tape

Full-spectrum triad pigments Permanent Rose, Winsor Blue (Red Shade), Winsor Lemon

Nos. 2, 4 and 6 rounds

Pencil

Salt

Straightedge or ruler

Look through your photo references for people you would like to include in your painting. I added the figures by tracing them from photographs. The drawing of my son was taken from a small photo, which I enlarged on a photocopier and then traced onto the watercolor paper. I traced both my daughter and husband directly from the photos. I knew that no matter how large or small they were, if I placed their eyes at the same level, they would end up being in the right spot for correct perspective. I fudged a little bit because all three people are not exactly the same height, but it still works well enough to be convincing. That's what I mean about not getting too hung up on the math. I use perspective as a tool and technique to support, rather than stymie, my creativity. Just remember to keep the eye level constant, that's the trick.

Reference Photographs

Draw Your Figures in the Piazza

Lenlarge the piazza painting on a photocopier, and trace just the buildings and pavement onto a piece of watercolor paper. Leave the figures out. Draw in the vanishing points and eye level in pencil (they will be well past your drawing so use a large enough piece of paper).

Trace your figures into the drawing, placing them wherever you want them. Make sure the eyes are placed at the eye level. Erase the eye level line once you have all the figures in place. Make adjustments to accommodate large height differences between your figures. Put the eyes of a very tall person above the eye level, and the eyes of a very small child below the eye level.

Tape the edges of the drawing with drafting tape. With the no. 6 round, underpaint by covering the whole paper with a very light, muted yellow shade. The yellow underpainting will infuse the painting with a golden, old-world accent.

Paint the Buildings and Roofs
Check with a straightedge to insure that the angles of the roofs lead to their vanishing points. Use the no. 4 round to paint the buildings with different shades of yellows, oranges, pinks and warm grays. Paint the roofs a terra-cotta orange color.

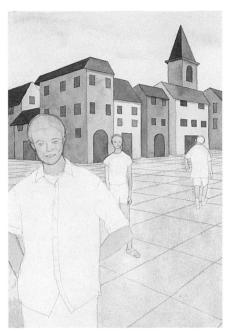

Paint the Pavement and Windows
Use the straightedge to check the tops and bottoms of the windows; be sure they lead to their vanishing points. Paint the windows dark blue.

Paint a light tan mixture all over the pavement of the square using the no. 6 round. While the paint is still wet, use the corner of a credit card or a bamboo pen to scratch along the lines of the pavement blocks. Inscribing into the wet paint produces darker lines when it dries. With a no. 2 round, paint a natural looking shade on the faces, and other areas on the figures where skin is showing.

Paint the Faces and Figures
With a no. 2 round, paint the faces
of the figures by referring to the photographs. Add the shadows cast by the
figures on the pavement. Darken the
shadow side of the roofs and the buildings. Take off the tape and admire your
painting. Congratulations! You have just
painted using two-point perspective.

Leave Out a Ground

My students laugh when I tell them that what I leave out of a landscape painting is more important than what I put in. I say that to remind all of us that we don't have to include every tree, branch and leaf we see. In fact, the more you refine your vision, the more successful you are at revealing the essence of your personal experience. Artist Raoul Dufy said,

"My eyes were made to efface what is ugly." By that I think he meant "Go ahead and take out that clutter if you want so we can see what you really, truly love about this landscape."

Before composing a landscape painting, take a good look at your subject, and identify the foreground, middle ground and background. Isolate each of these areas in your mind, seeing each one distinct from the other two. Practice this reframing process when painting outdoors or when working from a photograph. Then, give yourself license to simply eliminate one, or even two, of these grounds. What's left is the passionate distillation of your unique vision.

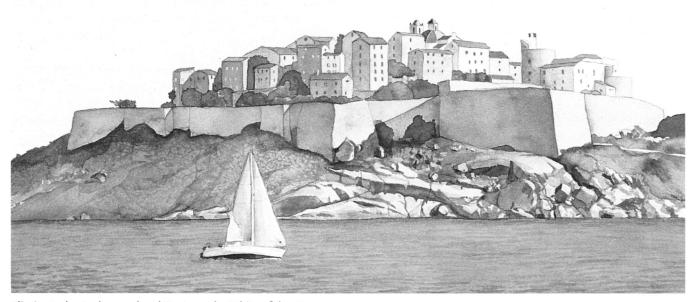

Eliminate the Background and Preserve the White of the Paper

This watercolor painting was inspired by a photograph taken by my friend, Robert Cantor, while on vacation in Corsica. After a mental reframing process, I decided to concentrate on the two elements most significant to me, the sea and sailboat of the foreground, and the citadel of the middle ground. I eliminated the background mountains, sky and clouds. Leaving the background area unpainted focuses attention on the stunning play of light and shadow on the walls, rocks and houses of the citadel, and the graceful sailboat skimming the brilliant blue sea. It also made it faster to paint!

Make Seven Paintings From One Landscape

Leaving out a ground is a liberating form of creative framing. You can easily paint the same scene several times, leaving out and including different grounds as you change your frame of mind. In fact, you can frame one subject at least seven different ways.

BackgroundMountains and sky

Middle ground Citadel and rocks

ForegroundWater and boat

Foreground, Middle Ground and Background

PHOTOGRAPH BY ROBERT CANTOR

Foreground Only

Foreground and Middle Ground

Middle Ground Only

Foreground and Background

Background Only

Middle Ground and Background

Panoramic Perspective

Another fun art escape exercise is the painted panorama. Practice creative framing by isolating a narrow slice of a photograph into a panoramic perspective. Use this technique to salvage a poor photograph or make a good picture even better. There are no rules about how long or how narrow the image should be. Whatever gives you the most exciting visual information should be your rule of thumb for determining the borders. You can also make what I call keyhole paintings by framing a narrow vertical slice of a photograph, in addition to the horizontal framing shown here.

PHOTOGRAPH BY ROBERT CANTOR

Isolate a Narrow Band

Robert Cantor took this photograph of the fourth 1998 Yankees-Padres World Series game. I isolated the action of the pitcher and batter, eliminating most of the photograph. The panoramic framework allows me to cut out the least interesting elements—the tops of the heads of the press in the front and much of the stadium stands. The charged energy of the game is heightened by paring down the photograph and reframing it to highlight what's most essential—the players and the closest fans.

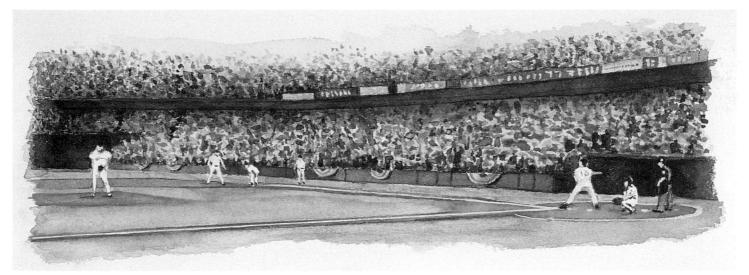

Watercolor With a Wide-Angle Lens

I like to fade the edges of my panoramas to create painted vignettes. This technique subtly suggests to the viewer that there is more to this scene, but I'm showing you the best parts. I painted this image on a piece of $9'' \times 12''$ (23cm \times 30cm) Arches 90-lb. (190gsm) cold-pressed watercolor paper. I used 90-lb. paper because I planned to display this painting in a folded frame format. The 90-lb. paper is best for this purpose because it folds crisply.

Get Involved in the Action

Sports are perfect for panoramic paintings because the interest is often spread over a wide field. Make paintings from quickly drawn sketches completed on site at ballgames. Or use the VCR to freeze-frame a highlight of a recorded sports event. Take your journal along with you to your children's and grandchildren's sports practices and events. I loved making panoramic drawings during my daughter's ballet classes, and while sitting on the bleachers at my son's baseball games. Here is a trick to capture the action. Freeze just one moment with a quick drawing, Use your one-minute drawing skills from chapter two to capture the basic gesture of the figures. Use your memory to add definition. Since the background isn't in constant motion, you can take your time filling in the surrounding details.

Make a Panoramic Viewfinder

MATERIALS

Heavy paper, 8½" x 11" (22cm x 28cm) sheet of white cover stock paper, or other stiff white paper

Pencil Ruler Scissors Reframe your photographs by looking at them through a panoramic viewfinder that you can easily make. See your photographs in a new light by cutting out distracting elements and focusing in on the visual action.

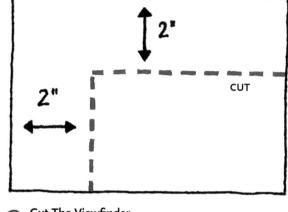

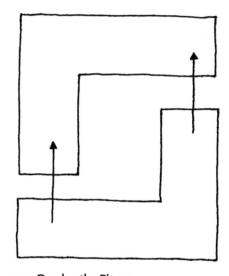

Cut the Paper in Half Cut an 8½" × 11" (22cm × 28cm) piece of white cover stock (or other sturdy white paper) in half, ending up with two identical 5½" × 8½" (13cm × 22cm) pieces.

2 Cut The Viewfinder
With a ruler, mark a 2-inch (5cm) border along the top edge and the left side edge. Cut along the lines, creating a 2-inch (5cm) wide right-angled corner. Cut the other piece of paper the same way.

Overlap the Pieces
Overlap the two right angle corners

to create a panoramic viewfinder. You can adjust the height and length of the opening to frame the visual action of your photograph to its best advantage.

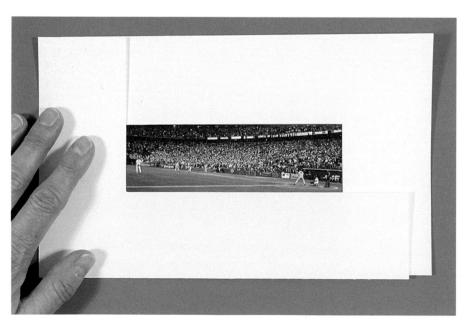

Frame Your Panorama

I moved and adjusted the two pieces of the viewfinder until I found just the right image to frame. I found precisely the elements in the photograph that I wanted to include in the painting.

Create a Folded Frame for Your Panoramas

MATERIALS

Arches 90-lb. (190gsm) cold-pressed paper, cut 9" x 12" (23cm x 30cm)

Bone folder or table knife

Craft knife

Double stick tape

Full-spectrum triad pigments Permanent Rose, Winsor Blue (Red Shade), Winsor Lemon

No. 2 round

Pencil

Straightedge or ruler

Bring your art out of the studio and into your life! Display your painted panoramas in a handmade folded frame on your desk, table or shelf. I like being able to artfully display my watercolors without having to go to the bother and expense of a traditional mat and frame. This handmade folded frame is a wonderful way to present art to your friends. Slip it into an envelope and fill someone's letter box with an artistic surprise.

For this exercise you will need a bone folder or a table knife. A bone folder is a book art tool used to fold paper by hand. The typical folder is made of white bone, about 6 inches (15cm) long and 1 inch (25mm) wide, with a tapered point.

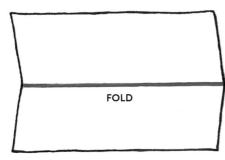

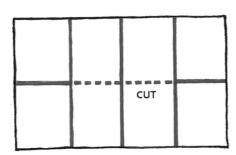

Fold and Cut the Display Frame When your painting is dry, make the folds as indicated. Always fold through one single layer of paper at a time for cleaner and more accurate folds. Slit the center of the paper with a straightedge and craft knife as indicated by the dotted line in the diagram.

Paint the Panorama

Fold a 9" \times 12" (23cm \times 30cm) piece of 90-lb. (190gsm) cold-pressed Arches watercolor paper in half. Score the line of the fold with a bone folder or the dull edge of a table knife blade before folding to get a crisp fold. Paint your panoramic composition on the bottom half of the folded paper. As you paint, the fold should be facing upward in a mountain position, rather than a valley position.

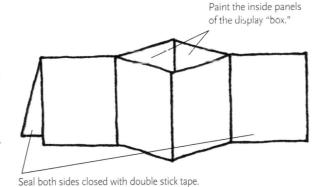

Display Your Painting

Paint the two inside panels with a color complimentary to your painting. Fold as shown and seal both ends with double stick tape. Give your creation to a friend or display it on your desk at work. This folded frame format makes a wonderful painted display card.

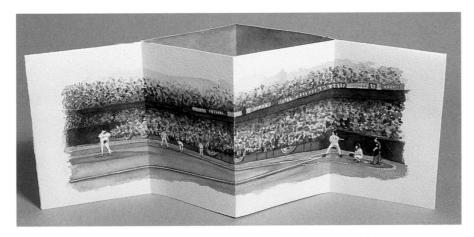

Panorama Folded Frame

The Sensory Perspective

Each of our five senses is a precious gift. Create a shrine of appreciation to each of them by painting abstract watercolors inspired by sensory mindfulness. The five-senses exercise invites you to be attentive to each of your senses, one at a time. What story is your sense of hearing telling you? What scents does your nose detect in the air right now? What taste sensations are lingering on your tongue? Where do your eyes pause and focus? How does your skin feel?

Discover a place of sanctuary. Is it a favorite park? A room in your home? A city street? A garden? Wherever that place is for you, take a few moments for what I call a sensory walk. Gently shut down the rest of your mind, and as you walk, simply listen, smell, see, taste and feel. Hold onto each impression for a moment. Heighten the awareness of your body and mind in space and time.

Become a vessel for a sensory engagement with the natural world.

Normally, we blend all our sensations together into one overall impression. The difference with this exercise is that you isolate each of your senses, and reflect on each one separately. This is a great way to creatively frame your personal perspective.

Sense of Hearing

I made this watercolor painting while I was sitting in a café by the yacht harbor in a small Mediterranean town in France. I was sitting peacefully, sipping a fresh-squeezed lemonade, listening to the gentle sounds of water lapping against the ancient seawall and splashing against the yachts anchored in the harbor. All of a sudden, an ambulance arrived, with a screaming siren. The red stripes in my painting represent the sound of the blaring horn, in contrast to the soft purples and greens representing the sound of the waves and water, and tinkle of cups and glasses in the café. After completing the painting, I cut it into four strips to create a collage. You can see that some sounds appear louder than others!

Sense of Taste

I like to make five-senses paintings on blank watercolor postcards. These are very handy, especially when traveling. This painting represents my sense of taste while in Turkey. I savored the fresh vegetables, the rich Turkish coffee, delicious black olives, tangy goat cheese...all that and more is in this watercolor! To create texture I scratched into the wet paint with the edge of a credit card, sprinkled salt onto the wet paint, and spattered red paint from my paint brush.

Sense of Touch

As I sat in the sun on the rooftop of my Istanbul hotel, I thought about all the sensations of touch I remembered from the previous two weeks in Turkey. Soft warm breezes and sharper, cooler winds, brisk dives into the sea, the smoothness of hand-polished woodwork on our boat, the relaxed feeling throughout my whole body as I lay on the deck as we sailed. It was a pleasure to recall all these sensory memories, and great fun to bundle them up into an abstract painting.

Sense of Smell

This little painting on a watercolor postcard represents what I perceived through my sense of smell as I took a sensory walk in a seaside town. The restaurants must have been preparing for lunch. My nose picked up the marine air of the sea and the pungent scents of the fisherman's fresh catch, as well as very tangible notes of garlic, olive oil and eggplant sautéing. All the scents were distinct, but they melded together into a beautiful sensory concoction.

Sense of Sight

I feel as if I'm back in the Italian seaside town of Portovenere when I see this watercolor. After a sensory walk, I settled into a fine café and encapsulated my impressions of sight into this abstract painting. As I look at it now, I recall the warm tan tones of the ever-present stone building blocks and the brilliantly colorful umbrellas of all the cafés lining the harbor. Sunshine and bright Italian fabric colors round out my impression. It's amazing how many memories these watercolors bring back. The act of creating from the treasury of your sensory storehouse is a powerful spiritual experience.

The Scents of Turkey

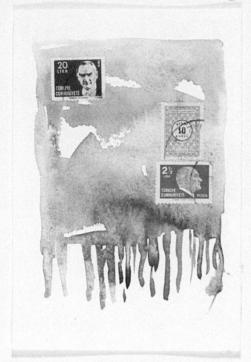

Durkish coffee brewing flowers at the Su Otel. flowers from Bill for Andrea. nuisty odor of old carpets. White goat cheese pungent goat scent. pine trees at Ageliman inlet. Sun screen. Salty sea breezes fragrant spices wafting up to the Rustem Pasha Camii from the Egyptian Spice Market. Cigarette smoke at restaurants. Sweet lily scent from my birthday flowers. diesel exhaust on the shops braziers selling corn on the cob. fish at markets. Surprisingly fresh air at wered

List Your Impressions

After you complete a five-senses painting, make a list of all the impressions that flood your mind. Just list them, don't bother with sentences. You will be surprised by how much awareness you carry, and how many feelings you can remember as you start listing them. This is a page in my artistic journal from a trip to Turkey. This watercolor is dedicated to the sense of smell. My friend, Andrea, gave me some Turkish stamps. I loved the colors and designs, so I added them to the image. I attached my painting to a page in my journal with some double stick mounting tabs. I enjoyed the process of remembering and reliving all the wonderful scents of Turkey. The listing format freed rne from worrying about grammar or sentence structure. I just kept listing and listing until I ran out of room.

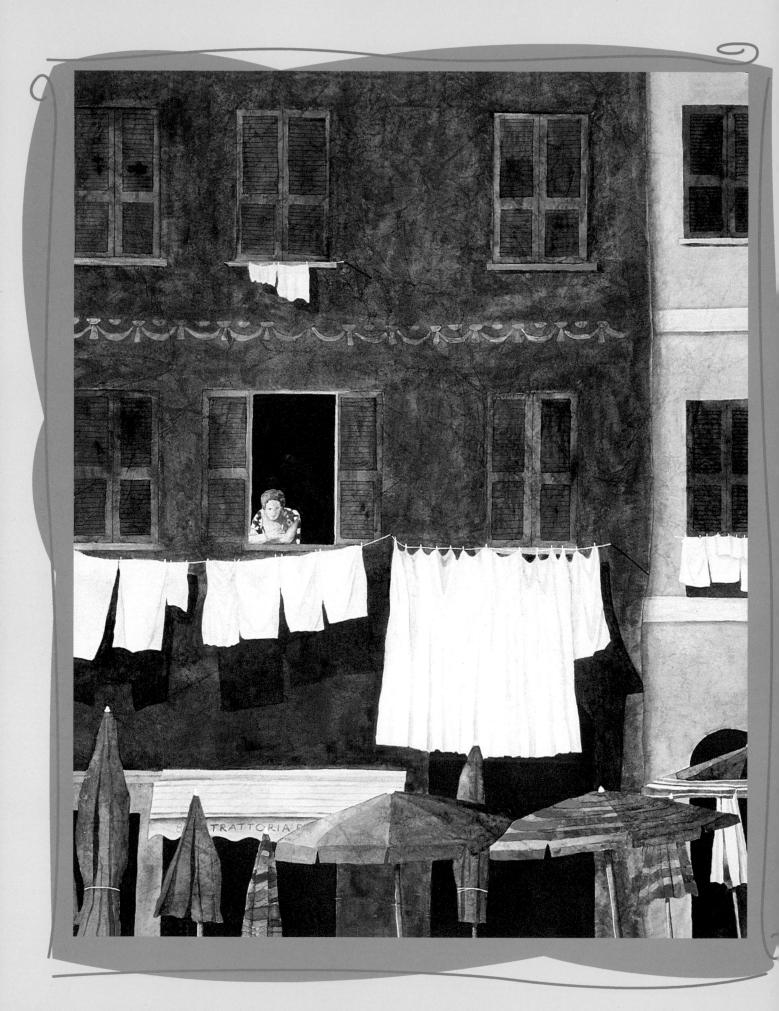

Art Assemblage, Collage & Other Inspiring Ideas

that I don't need a plan to begin. Collage is a dynamic tool for spontaneous design. Transform the ephemera of daily life—candy wrappers, ticket stubs, bottle labels, postcards and stamps—into enduring images. My spirit of invention soars when I construct abstract assemblages, and paint on

aking collages is exciting. I love the spontaneity of cutting

I am my sketchbook.

~ Pablo Picasso

unique collaged surfaces.

This chapter is a resource manual of my favorite collage techniques, time-tested and shared with many friends, students and col-

leagues. All you need is your collage tool kit to get going on new, energizing page-a-day creations. You will learn how to make watercolor mosaics, painted paper cutouts, paper weavings, crinkled paper collages, and found-object collages.

Each project is an open door to a fresh approach in your artistic journal. There are many page-a-day ideas and creative prompts to trigger your imagination. I hope you enjoy the experimentation of art assemblage, and the invitation to celebrate the day in new invigorating ways.

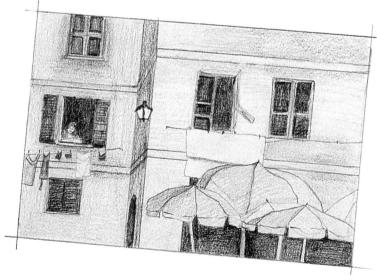

WASH DAY, VERNAZZA
Watercolor on crinkled Masa paper collage, mounted on
Arches 140-lb. (300gsm) cold-pressed paper
26* × 20* (66cm × 51cm)
Collection of Randall Vemer

Watercolor Mosaics

I think of watercolor mosaics as inventions of the soul. Make a mosaic-of-the-moment in your journal and see what springs forth from your brush, your hands and your spirit.

There is infinite diversity to this simple format. Expand your visual vocabulary with abstract collage art. Some artists have become positively addicted to this art habit.

Cut Pieces in Random Sizes

I had fun assembling this design to commemorate a day spent with friends. I tried to recreate the blues and greens of the river and sky on my painted paper. I cut the rectangles and strips in random sizes for variety, some large, some small and some medium. The composition came together quickly after I cut the pieces. I included both the sailboat and boathouse in the finished design. It all started with rectangles and strips.

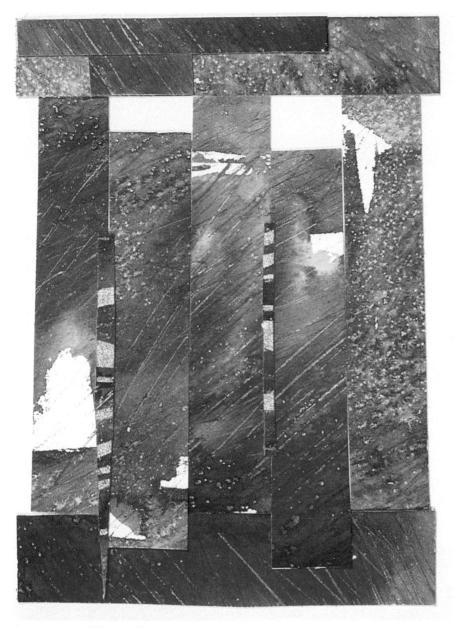

Free Your Spirit With Mosaic Art

A few years ago, my family had just begun a very special yearlong sojourn in Europe. I was so excited to begin our adventure, and so full of ideas and dreams of the artwork I would produce. There was one problem; I was paralyzed with the limitless potential. The French countryside where we started our sabbatical was so heartbreakingly beautiful. How was I going to paint it? How could I do it justice? I broke through my painter's block by creating watercolor mosaics. I started painting paper, simply replicating the colors of the French hills, vineyards, farmhouses and flowers. Then I cut my French-inspired watercolor papers into rectangles and strips. I designed them into abstract collages and glued them into my brand new journal. I broke through the barrier of "what to do?" with a liberating artistic invention.

Express Yourself in Colorful Abstractions

I created this watercolor mosaic in response to the tragic events of September 11, 2001. I used color and design, rather than a direct depiction, to reveal my emotions. I painted a piece of paper with the colors of intense fire and smoke, then cut it into strips before gluing the collage into my journal.

9.11 NYC Watercolor and collage on Arches 140-lb. (300gsm) cold-pressed paper 5° × 6° (13cm × 15cm)

Use Black or Colored Backgrounds

Let the Subject Emerge

Take a piece of watercolor paper and simply enjoy painting on the paper, without giving any thought to your subject matter. The subject, at this moment, is you. Remember, the muse comes to the moving brush. You may want to paint more than one piece of paper, as you loosen up. If you like, play some music while you paint.

Pick one of your painted papers and cut it into rectangles and strips. Create a watercolor mosaic, allowing the subject to surface unbidden. Give your mosaic a title only after you finish composing your design. Perhaps you will discover something about yourself in the process. Sometimes I don't know what the inspiration for an artwork is until it is done. This is part of the magic of art.

Take a look at the watercolor mosaic, Friday Night Chopsticks. You can see it in its original form on top, and recreated against a background of black cardstock below. It's surprising to see the brilliant mosaic pieces as they appear against different backgrounds. Experiment by varying background colors for your mosaics—it all adds to the spirit of innovation. You can create your own version of Friday Night Chopsticks using the step-by-step demonstration on pages 84–85.

FRIDAY NIGHT CHOPSTICKS Watercolor, gold leaf and collage on Arches 140-lb. (300gsm) cold-pressed watercolor paper $5^{\circ}\times6^{\circ}$ (13cm \times 15cm)

Add Texture Using Special Effects

One of the wonderful attributes of watercolor is the ability to add fascinating texture to the painted surface. Here are four of my favorite techniques. Have fun and experiment with all four as you create painted papers for your watercolor mosaics. Use one or combine two or more of these techniques for added surface richness.

Scratch

Scratch a pointed object into wet paint and you will produce a dark line on your paper. The paint puddles into the valleys created by the impressions made with the pointed tool. On the right, I inscribed lines with the tip of a bamboo pen; the dark marks in the middle were made from the point of my scissors. Scratching into dry paint creates white marks as you reveal the paper. The white marks on the left were made by scratching with a craft knife.

Spatter Paint

I spattered yellow paint on top of wet red paint. When the red background was dry, I filled a toothbrush with blue paint and ran my finger across the bristles to produce a fine blue paint spray. The best way to spatter with a paintbrush is to knock your loaded brush against your other hand, which is resting securely on the table for support—not up in the air. Spraying clean water onto wet paint with a sprayer will produce light spatter marks.

Sprinkle Salt

Scatter salt from a shaker over your painting while the paint is still shiny wet. As the wet paint dries, the salt absorbs the pigment, leaving white, starlike shapes. Experiment with different kinds of salts—kosher, margarita, table—for different versions of the same natural phenomena.

Add Metallics

I include Krylon leafing pens in my drawing tool kit. They come in gold, silver or copper. I love the shimmering metallic accents stroked over dry watercolor paintings. The Krylon pens are great because of the richness of their metallic coverage.

Dry Mount Glue Technique

MATERIALS LIST

Acid-free rubber cement Arches 140-lb. (300gsm) cold-pressed paper, cut to fit inside sketchbook

Full-spectrum triad pigments Permanent Rose, Winsor Blue (Red Shade), Winsor Lemon

Krylon leafing pen: gold, silver or copper No. 6 round

Pen tips and pointed tools for texturing Rubber cement pick-up tool, or gummed eraser

Salt

Scissors

Scratch paper for gluing

The best way to adhere all your mosaic pieces to a paper surface is with the dry mount glue technique. The great advantage of this method is that you don't have to glue each mosaic piece individually.

Here is how it works: Cover the back of your uncut, painted watercolor paper with rubber cement. Let it dry. Cover the paper where you want to mount your mosaic with rubber cement and let it dry. Now, cut your collage pieces out of the painted paper. Simply press each collage piece onto the paper substrate, and the two dry glued surfaces will bond together. Follow the step-by-step instructions below. You will save lots of time and make gluing a breeze with the dry mount gluing technique. Be sure to buy acid-free rubber cement (Elmer's makes one) to preserve your artwork.

Create Color and Texture on Watercolor Paper

Use the full-spectrum triad to paint rich colors onto Arches 140-lb. (300gsm) cold-pressed paper. Inscribe into the wet surface with the bamboo pen. Sprinkle salt and spray clean water onto the semiwet paint. When dry, add some calligraphic marks with the Krylon 18 Kt gold leaf pen. At this point in the process the subject is still unknown. Simply enjoy playing with the paint and have fun layering textures and colors. The subject will reveal itself as you continue.

Apply Glue to Your Painting

Lay your dry painting face down on a piece of scratch paper. Spread an ample amount of acid-free rubber cement over the back and past the edges of your painting. Let it dry until it is no longer sticky to the touch.

Apply Glue to Your Journal Page

Spread acid-free rubber cement over the page in your journal where you want to adhere the mosaic. Be sure to apply rubber cement over a larger area than you imagine your finished design will be so that you have freedom when placing the pieces. Let the glue dry until it is no longer sticky to the touch.

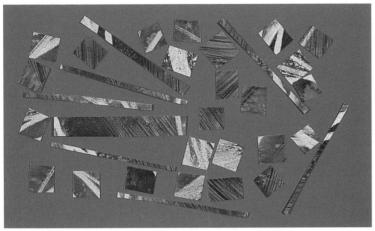

When the rubber cement on your painting is thoroughly dry and no longer sticky, cut your painting into strips about 1-inch (25mm) wide. Now cut most of the strips into squares. Cut freely—don't bother measuring the strips and squares with a ruler. It is not important to produce rigidly uniform shapes. Cut some of the wide strips into thinner strips for accent pieces. Create a large pile of painted mosaic rectangles.

Design Your Mosaic

Design Your Mosaic

Lay all your cutouts on a separate piece of paper and pick the ones that attract you. Play with the pieces until you find a pattern that appeals to you. You won't use all the pieces. If you want to cut the pieces again, go ahead and trim. Turn your composition upside down and sideways to see if it is balanced. You'll see your mosaic with new eyes simply by viewing it from a different angle. You might even like it better upside down.

Transfer Your Design Onto the Glued Surface

Replicate the pattern you created by picking up each mosaic piece and setting it onto the glued paper surface. Each piece will bond to the glued paper because of the contact of dry rubber cement on both surfaces. After you have placed all the pieces, use a rubber cement pick-up tool or a gummed eraser to rub away the excess rubber cement. The subject of your mosaic will emerge as you create your design. Finish your mosaic with a title and your signature.

Painted Paper Cutouts

Henri Matisse created vibrant collages by "drawing with scissors." Inspired by the freedom of his method, I create my own version of painted paper cutouts in my artistic journals. Design without drawing—let your scissors describe the shapes for you. Don't like the shape? Just cut again!

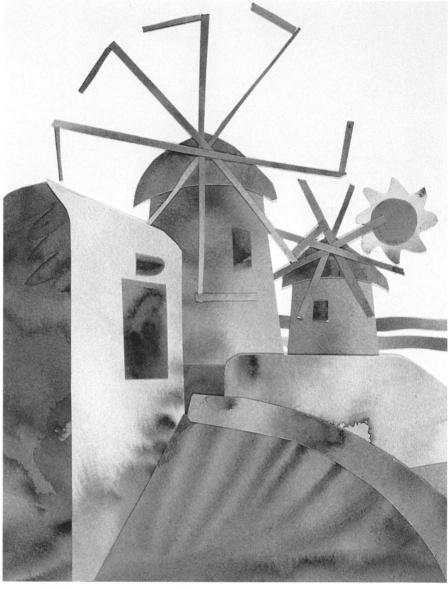

Contrast Brilliant Colors Against a White Background

Monica Wheeler interpreted her love of the island of Mykonos in this bold magenta watercolor cutout. You can almost feel the warm sunset glow over the windmills so typical of this Greek island. Against the white paper of her journal page, the monochromatic color is brilliant in its simplicity.

WHY MYKONOS?

Monica Wheeler

Watercolor on Arches 140-lb. (300gsm) cold-pressed watercolor paper

10° × 8° (25cm × 20cm)

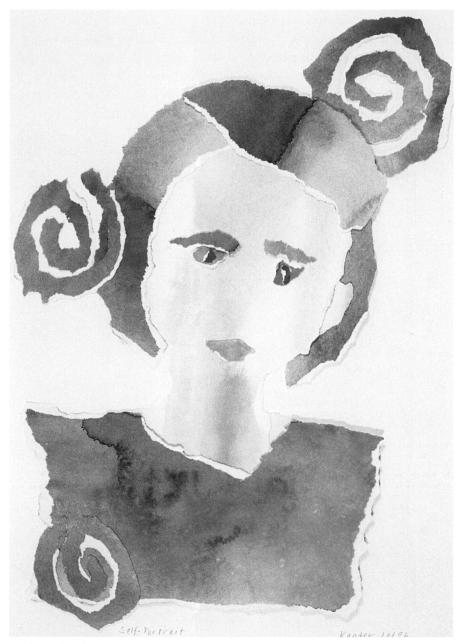

Tearing Painted Paper

Tearing paper for collages is a freeing way to create shapes. It's hard to get too fussy when you are tearing paper. I love the raw white deckled edge of torn painted paper. The white outline allows you to draw attention to shapes in your composition. The torn spiral patterns added to this self-portrait are ancient Greek symbols for chaos and energy. On some busy days, that motif seems like the right symbol for my life! It was restorative to take some time for myself out of a day full of activity to create this sketchbook self-portrait.

SELF-PORTRAIT Watercolor on Arches 140-lb. (300gsm) cold-pressed watercolor paper $8^{\circ} \times 11^{\circ}$ (20cm \times 28cm)

Cutout Collaborations

Ask a friend or family member to collaborate on a portrait. Ask them to loosely paint a piece of watercolor paper, covering it from edge to edge. Have them select colors they are particularly drawn to. The colors should represent something about that person. If your friend or family member gets stuck with that concept, ask them to think about the colors they love to wear. This usually represents a person's favorite colors.

Use the painted paper to make a cutout portrait of your subject. Try the torn paper technique for a very personal and uncomplicated image. Give the original collage to your friend or family member as a gift, and make a color copy to insert into your journal.

Create a Colorful Background Blanket

MATERIALS

Acid-free glue stick

Arches 140-lb. (300gsm) cold-pressed paper, 10" x 14" (25cm x 36cm) piece and one cut to fit inside your sketchbook

Full-spectrum triad pigments Permanent Rose, Winsor Blue (Red Shade), Winsor Lemon

No. 6 round

Scissors

Scratch paper for gluing

This painted paper assemblage recalls the fish, sailboats and sea of the island of Corsica. The background blanket is painted in turquoises and blues—brilliant Mediterranean colors. My full-spectrum triad eased the blending of these exuberant hues. I made this painted paper collage while on a ferry ride from Corsica to Nice. Out came my scissors, glue stick and a lot of memories of a week in Corsica. What a wonderful way to while away an hour or two.

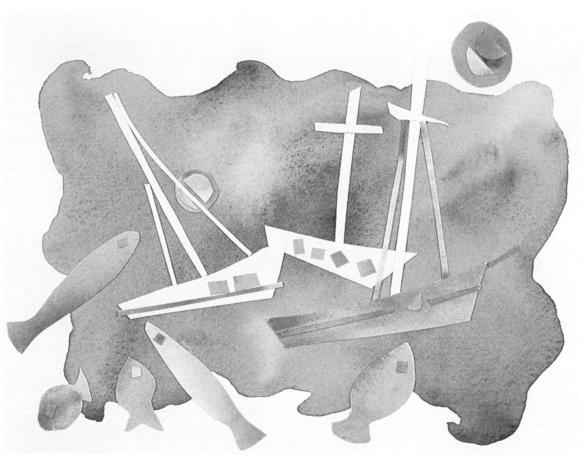

CORSICAN MEMORIES Painted paper on Arches 140-lb. (300gsm) cold-pressed watercolor paper $8^* \times 10^*$ (20cm \times 25cm)

/ Paint a Colorful Wash

Paint an entire piece of cold-pressed watercolor paper with loose splashes of colors derived from your subject. You don't need to describe the subject as you paint—just record the colors of the landscape, objects or figures in your theme. Have fun and paint freely to cover the paper with unself-conscious broad color washes.

Create a Background Shape

On another piece of cold-pressed watercolor paper, paint a colorful background shape—a large rectangle, ellipse, circle or other shape. Think of the painted background shape as a blanket to hold your cutout shapes. Vary the blanket shape to indicate the atmosphere of your theme. This painting suggests the waves and colors of the sea. Some other possibilities are a starry dark blanket for a night scene or a field of green grass for a pastoral subject.

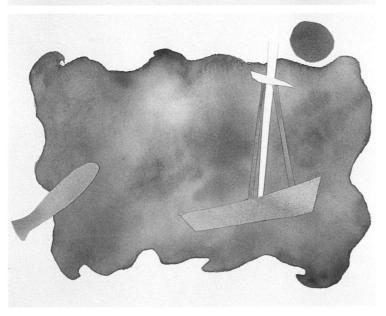

Glue Your Shapes on Top of the Background

Take your painted paper from step 1, and cut shapes that will float on top of your painted background blanket. Cut out fish, boats and sun shapes with your scissors. Move the pieces around to decide where to glue them. Use an acid-free glue stick. It's surprising how pleasurable painting, cutting and gluing can be.

Paper Weaving

Weave a Garden View

This page is from a journal I made a few years back. Its a very uncomplicated paper weaving-that only took a few minutes. I used two blank watercolor postcards to make the paintings. On one, I quickly painted the greens of the foliage in my garden on a June day. On the other, I painted the colors of the late spring flowers, budding and blossoming in my little garden patch. I casually cut the paintings into strips and wove them together. You can see that I didn't bother cutting the strips evenly or in perfectly straight lines. I like this informal look-especially in my journal. I picked one of the flowers and tucked it underneath the paper weaving. It's pleasing to look through my sketchbook and be reminded of a garden that grew several years ago.

Create unique paper weavings in your artistic journal. Merge two paintings or photographs together into a construction that combines both in a fascinating way. The end result is greater than the sum of its parts. It's exciting to see how your woven image turns out. There is always a happy surprise when you are done.

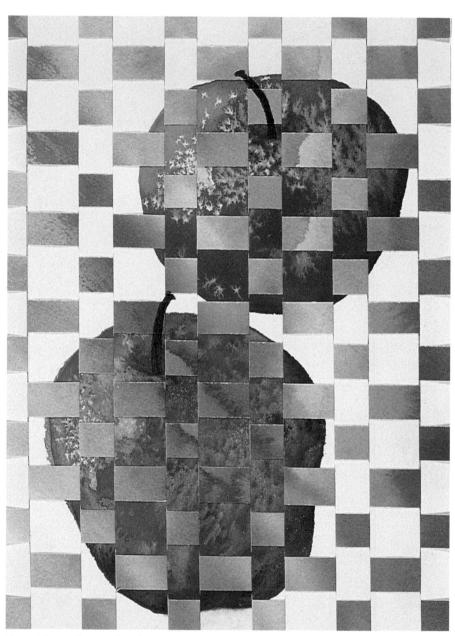

The White Background Makes the Subject Stand Out

One way to create a dramatic paper weaving is to leave the background white. I painted two apples onto a piece of Arches 140-lb. (300gsm) cold-pressed paper, leaving the background unpainted. The second painting is a wash of red and green apple colors. I like the way the apples stand out strongly after weaving the two images together.

BELLE MELE PER FRANCO Watercolor on Arches 140-lb. (300gsm) cold-pressed paper $7^{\circ} \times 10^{\circ}$ (18cm \times 25cm)

Weave a Wavy Memory

My daughter, Laura, made a collage for her college dormitory room out of two identical photocopies of a favorite photograph of our cat, Hercules. She cut each one into vertical strips, without a ruler—just cutting with scissors freehand. Using the dry mount glue technique, she adhered each strip to her page with rubber cement. She made an original, spirited image from two matching photocopies, just by cutting and pasting twin strips next to each other.

Your finished collage will be twice the width of your original photo because of doubling the identical strips. Crop both photos on the sides to focus attention on your subject. In this way you can temper the width of your finished artwork.

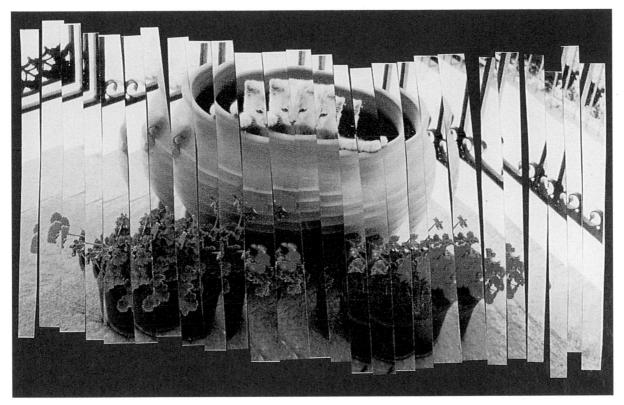

Double the Impact

The dry mount gluing system is perfect for this project. Follow the same procedure described on page 84. Before you cut the two identical photos, photocopies or postcards, spread rubber cement over the back of each one and a page in your artistic journal.

When the rubber cement is no longer tacky, cut each image into vertical strips, about ½-inch (6mm) wide. Be sure to keep all the pieces in order. Lay the strips down onto the dried rubber cement on your journal page. In this case, Laura used a piece of black mat board as her background, rather than her journal. Place each twin strip next to its mate. You can offset the strips a bit to create an animated uneven edge.

HERCULES Laura Kanter Paper weaving from photocopies, glued onto black mat board $5^{\circ} \times 8^{\circ}$ (13cm \times 20cm)

Weave Two Themes Into One Subject

MATERIALS LIST

Arches 140-lb. (300gsm) cold-pressed paper, 4" x 6" (10cm x 15cm) cut to fit inside sketchbook (two pieces) or two 4" x 6" (10cm x 15cm) postcards

Cutting board

Full-spectrum triad pigments Permanent Rose, Winsor Blue (Red Shade), Winsor Lemon

Masking or drafting tape No. 2 round Scissors or craft knife Straightedge or ruler

Paint Two Different Ways

I Identify two aspects of the subject and paint each of them on a 4" × 6" (10cm × 15cm) piece of watercolor paper or a postcard. Paint one image depicting the sky, clouds and sea. Paint the second one showing the colors and textures of the beach grasses and flowers.

Weave two paintings together to combine two observations of one theme, in an extraordinary way. One painting depicts the sky, clouds and watery waves of the seashore. The other describes the beach grasses and flowers growing near the dunes.

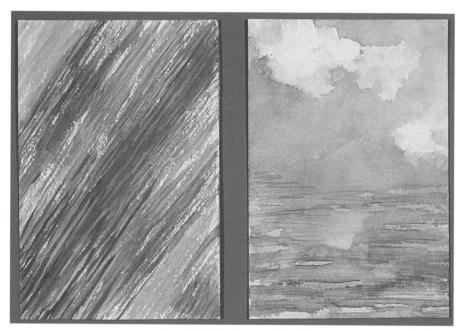

Cut Vertical Strips

Set the sky/clouds/sea painting on a cutting board, stretch drafting tape across the top ¼-inch (6mm) edge of the painting and secure it. Use a craft knife and ruler to cut the painting into vertical strips, cutting them alternately ½-inch (12mm) and ¼-inch (6mm) wide. Cut the strips only up to the lower edge of the tape, leaving the painting uncut underneath the tape.

Cut Horizontal Strips
Use a craft knife and cutting board to cut the beach grass/flower painting into horizontal strips, again alternating between ½-inch (12mm) and ¼-inch (6mm) widths. This time cut all the way across, keeping the strips in order.

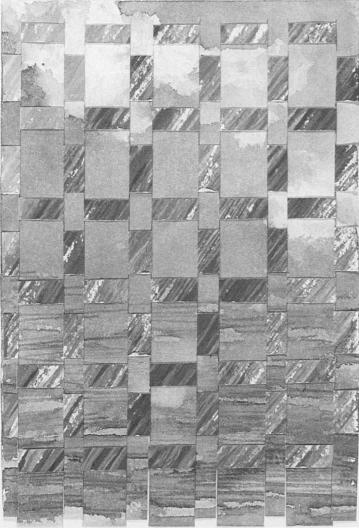

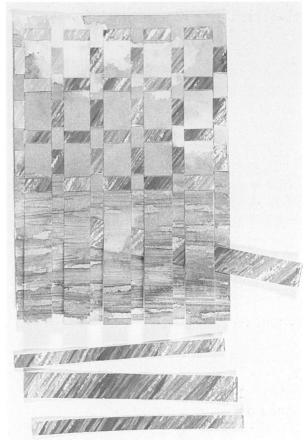

Weave the Strips Together
Take each horizontal strip and weave it into the vertically cut sea painting. Alternate rows beginning over and under, then under and over. Alternate between the ¼-inch (6mm) and ½-inch (12mm) strips to create an attractive pattern. When you finish weaving, tape the back of the collage along the edges to keep the strips from unraveling.

SEA WEAVE
Watercolor on Arches 140-lb. (300gsm) coldpressed watercolor paper
4" × 6" (10cm × 15cm)

Crinkled Paper Collage

Mingle the traditional and the innovative by painting on crinkled paper collage. Crunch up a piece of paper and unfold it—you have just created a strikingly textured surface for watercolor. Paint directly on the crinkled paper or glue it onto a piece of watercolor paper before painting. In both cases, a fantastic veined surface will appear as you apply watercolor. This wholly unique effect is a wonderful tool to add to your artistic repertoire.

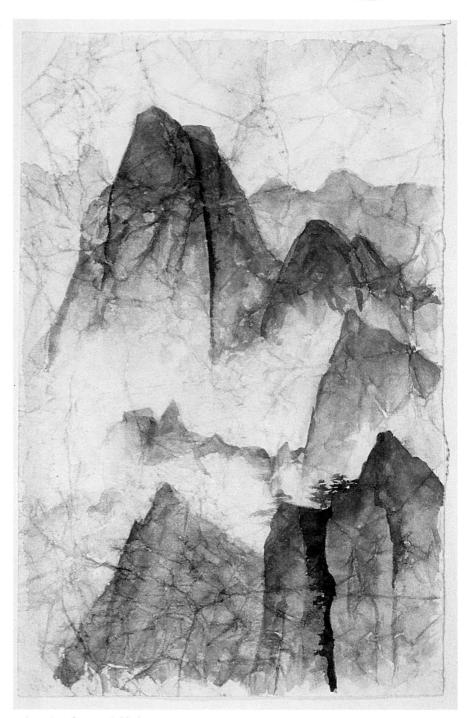

Paint Directly on Crinkled Paper

Japanese Masa paper is similar in appearance to white butcher paper, but it is much stronger when wet. I crunched up a piece of unwaxed Masa paper. Then I unfolded the paper and started painting with watercolor. When finished, I lightly tacked this watercolor sketch onto my journal page with a dab of glue at each of the four corners. I love the instant texture that developed on the painted mountains. As the wet watercolor soaks into the grooves of the crinkles, batik-like lines and veins appear on the surface. This quick sketch was in preparation for *Yellow Mountains, China* on page 10. I often use my artistic journal for experimentation before beginning larger works.

Paint on Crinkled Masa Paper With Ink

This is another example of painting directly onto crinkled Masa paper. I let the creases and bumps in the paper help make the tree shapes. I loaded a no. 6 round with black sumi ink. Holding the brush on its side, I stroked it over the bumps and folds of the crinkled paper, which I did not stretch out completely flat. The brush hit the raised paper folds and missed the areas inside the creases. When the large tree mass was established, I added a few lower branches and leaves to the edges using a no. 2 brush held upright in the customary fashion. Next I painted the trunks of the trees. When done painting, I completely unfolded the paper and glued it onto the stiff surface of my sketchbook cover using white PVA glue. When glued flat, I used a carved stone chop to stamp my name in Chinese characters. Ink paintings on crinkled paper convey a distinctively Eastern simplicity and elegance.

Make Botanical Studies With Crinkled Papers

Lines and veins appear quite naturally in crinkled paper collages painted with watercolor. This distinctive textural effect makes a beautiful surface for botanical subjects. You can create amazingly lifelike leaves and petals. This painting was made with crinkled Masa paper, glued onto 140-lb. (300gsm) watercolor paper. I stained the whole sheet of crinkled paper with light tones of blues and violets after it was glued onto the watercolor paper.

FEBRUARY BULBS
Watercolor on crinkled Masa
paper mounted on Arches 140-lb.
(300gsm) cold-pressed paper
13" × 20" (33cm × 51cm)

Rich Color and Texture

MATERIALS

Arches 140-lb. (300gsm) cold-pressed paper

Brayer

Clothes iron, set on the lowest temperature

Elmer's white glue or acid-free PVA glue Glue brush

Nos. 2, 4 and 6 rounds

Sun triad pigments: Holbein Marine Blue, New Gamboge, Permanent Magenta Spray bottle filled with water

Spray bottle filled with water

Plastic wrap

Unwaxed Masa paper or white butcher paper (not as strong when wet) 2B pencil

Create a naturalistic texture for your floral paintings with this special collage technique. The creases of the crinkled paper collage make lifelike veins and tonal variations in the painted flower petals and leaves. Follow the step-by-step instructions to make a crinkled paper floral painting.

Draw the Image

One side of the Masa paper is smooth and shiny, the other side is rough. With a 2B pencil, draw a floral design on the shiny side of the paper. After drawing, crush the Masa paper into a tight ball. Don't be afraid of crumpling the paper too much, the creases create the textural effect. Unfold and gently press the paper flat with your fingers.

Spray the Masa paper with clean water. With a no. 6 round, loosely paint on top of your drawing. Veins will appear where the paper is creased. Use pure New Gamboge and Permanent Magenta, and a purple mixed from Permanent Magenta and Marine Blue for the flowers. Mix a bright green using New Gamboge and Marine Blue for the leaves, and light Marine Blue for the vase.

When dry, flatten by lightly ironing on the back side of the painted Masa paper. Glue the painting onto a slightly larger piece of 140-lb. (300gsm) cold-pressed watercolor paper with white or acid-free PVA glue. Cover with plastic wrap to protect the Masa paper, and roll with a brayer to press flat. Remove the plastic wrap, and let dry.

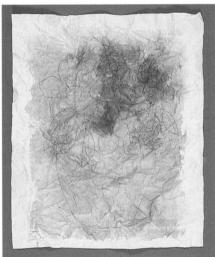

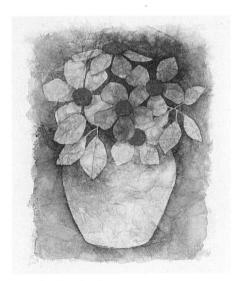

Define the Image

Make the subject appear by painting the negative shapes behind it. Use a no. 2 round to paint darker values of the same color mixtures as in step two, to darken the shapes behind the flowers, leaves and vase. Leave the subject untouched to preserve the freshness of the underpainting. The creases in the Masa paper emerge as you apply wet paint to the surface. The more you paint, the more the creases appear. Finish by adding red centers to each of the flowers with a no. 2 round using a mixture of New Gamboge and Permanent Magenta.

Found Object Collage

The Weekend Collage

This week, keep a resealable bag with you to collect all the labels, ticket stubs, menus, newspaper clippings and attractive papers you find. Then, over the weekend, cut, tear and arrange the papers into a collaged composition. Look for variety in color and shape, layering translucent papers on top of others for a subtle effect. Center the eye on a dominant area or focal point that is supported by all the other design elements. Lightly paste the collage pieces in place temporarily so you can make changes if you wish. When you have settled on your composition, apply glue from a glue stick over the back of each piece. Press down so that all the shapes lay flat when dry. Don't forget to take a moment to admire the new pages in your artistic journal.

Thomas Edison said, "To invent, you need a good imagination and a pile of junk." What some call junk, I call treasure. Recycling is an art form. What normally is lost, instead, can be turned into found object collages. Gather a collection of attractive scraps—newspaper clippings, tickets, bits of wrapping papers, handwritten letters and notes, leaves, flowers, printed E-mail messages—all these bits and pieces have personal meaning and memories. Transform these everyday artifacts into page-a-day artistic journal creations.

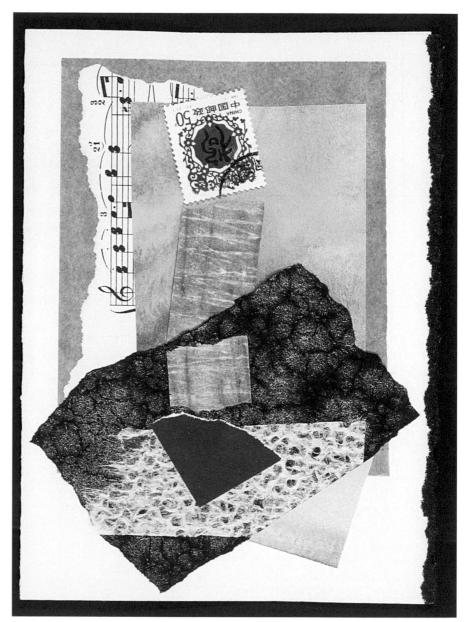

Reclaim Old Sheet Music and Candy Wrappers

Recently I found some tattered sheet music, yellowed with age, at a secondhand store. I love incorporating bits of sheet music into my collages. I also included a stamp I peeled off of a postcard from China. The transparency of the white rice paper on top of the black torn rectangle creates a subtle layered effect. It was fun combing through my scrap paper collection and combining bits and pieces into this collage.

Labels Inspire Art

A label from a bottle of mineral water found its way onto a page in my journal. The bright sunset image caught my eye. It became the inspiration for my journal watercolor painting. I'm glad I tore the label off the bottle and saved it. Sometimes inspiration for artwork comes from the most unexpected places. The first step is collecting fabulous scraps, and gluing them into your sketchbook—the best place to experiment with new ideas, images and approaches.

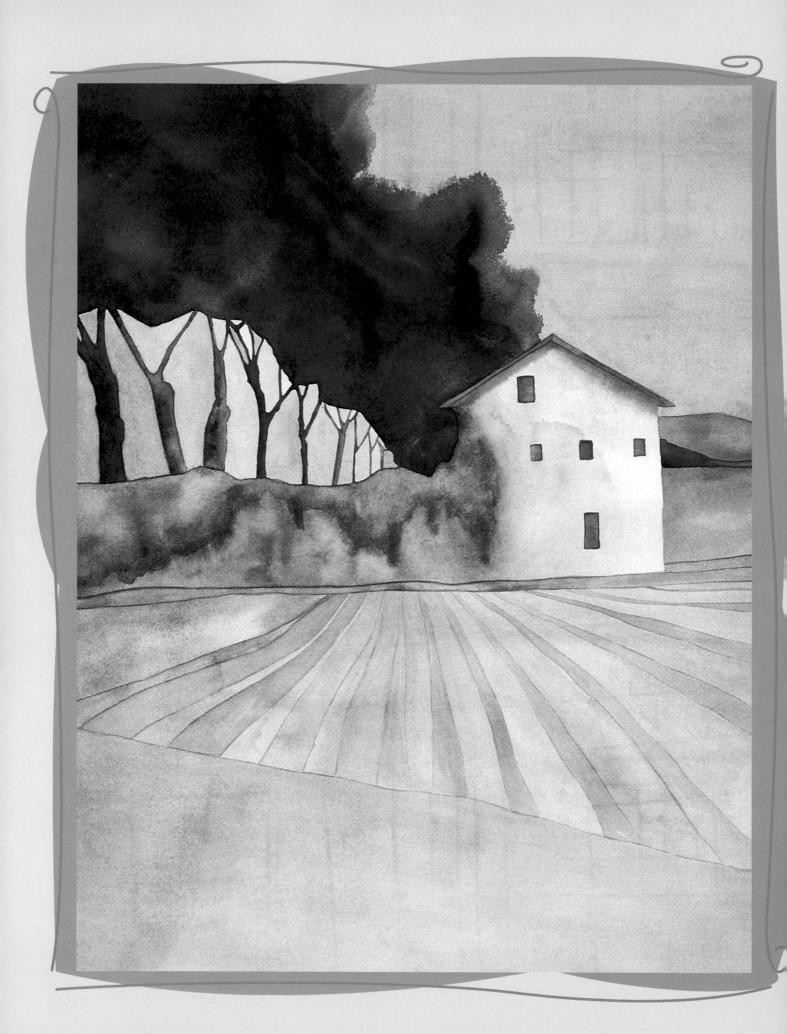

Let's Go Outside and Paint!

love to paint outdoors. In this chapter, I'd like to share with you my joy of landscape painting. My best work comes when I am relaxed and enjoying myself. My four-step strategy to plein air painting helps me to "paint the way a bird sings"—freely, intuitively and passionately.

I would like to paint the way a bird get you there? Over sings.

-Monet

How do you get from seeing to painting? What are the steps to get you there? Over the years, I discovered four key steps to painting a landscape. Each step leads you quite naturally to the next one—from inspiration to shapes to values to color.

An essential element is painting with passionate color, rather than photographic color. In this chapter, you will learn how to convey the mood of the landscape with my four color triads. It's time to get acquainted with the dynamic personalities of what I call the full-spectrum, earth, water and sun triads!

No two artists will capture a scene in the same way. Your impressions reveal what only you distill from a moment and place in time. It is a delightful truth that everyone experiences the kaleidoscope of life uniquely. I hope the projects and suggestions in this chapter will persuade you to go outside and paint your world!

PROVENCE: SUMMER ABUNDANCE
Watercolor on Arches 140-lb. (300gsm) cold-pressed paper
28" × 20" (71cm × 51cm)
Collection of Susan Monti

Inspiration: The First Step

If we create from the heart, nearly everything works. If from the head, almost nothing. ~ Marc Chagall

The first step allows you to absorb the beauty of nature. You can be inspired by any number of aspects in a natural setting. The important thing is that you recognize what stirs you. Let that spiritual force propel your painting. Although this is the single most significant step to painting with expression, strangely, it is often overlooked. Get in touch with your emotional response to the landscape, otherwise you will have nothing to communicate to the viewer.

Take advantage of all your senses: sight, sound, touch, smell and taste. Look this way and that, until you find one view that attracts your attention more than others. Take a moment to ask yourself, "What is it about this place that I want to take home with me? What do I want to remember?" That is the element you need to emphasize in your painting.

Always refer back to your original source of inspiration. My quest is to produce paintings of beauty, originality and meaning. This initial step reminds me to put first things first, to reflect on what inspires my sight and my soul, and incorporate that essence in my artwork. As Paul Cézanne said, "Painting from nature is not copying the object; it is realizing one's sensations."

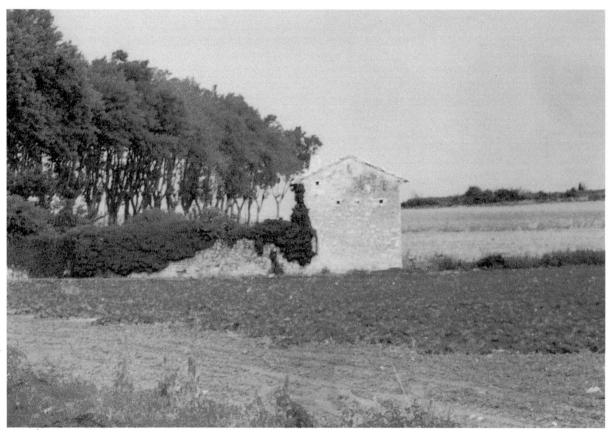

Record Your Inspiration

Painting landscapes *en plein air* has deepened my experience as an observer and traveler. I always take photos to include in my artistic journal. But a photo can never substitute for the on-site, in-the-moment acknowledgment of your sensations. This photograph was taken of a landscape in the south of France, and is the inspiration for *Provence: Summer Abundance* on page 100. I wanted to encompass all my passion for this countryside in my watercolor painting.

ureillac · France · 2:30 p.m. · August 10 · I'm sitting on the sunny patio of our rustic rented house ... my feet on the warm paving stones ··· crickets er locusts chirp & buzz all around, then suddenly stop until the bug chorus starts up again · · · the vineyard bursts with fresh green shoots or heavy leaves ... everywhere I look I see et feel & touch life ... even the earth is alive with a robust red-amber hue ... the sky too is lit with life ... is it the heat that makes it shimmer? ... a light breeze whispers at my neck of hugs legs ... the breeze brought the scent of lavender, rosemary of thyme ... I can almost taste the tang of the herbs on my tongue ... I want to stitch together the abundance, fertility, fruitfulness, & vitality of this radiant & vibrant landscape into my painting Possible title . Summer Abundance

Brainstorm Your Emotional Response

After taking some moments to drink in the landscape, I like to record my sensations by writing in my artistic journal. I always make note of the time of day and the date. In the process of brainstorming my sensory reactions, I find it easy to distinguish vivid sources of artistic inspiration.

Write It Down

Start by recording your impressions of a landscape in your sketchbook journal. Write for ten minutes continuously, without stopping. Chronicle your primary reactions and responses, without editing. A variation on this method is to write without lifting your pencil off the paper, one word flowing right into the next. I find this practice quite liberating.

Here are some questions to get you going:

- Me How does the air feel on your skin?
- Which colors attract your eye?
- What fragrances or odors does your nose detect?
- What sounds do you hear?
- What does your sense of taste detect?
- ✓ Does the light or shadow in one area particularly attract you?

After your ten-minute free-write, give your painting-to-be a working title, even before you begin painting. This working title will gently remind you to always refer back to your original inspiration, directing your attention to what you most want to communicate in your painting. The title can be descriptive, *The Red Door*, or metaphoric, *Wild and Free*. Remember: this is your own unique experience. Celebrate it!

Shape Plan: The Second Step Drawing is not form, it is a way of seeing form. ~ Edgar Degas

Step two is simple; less is more! This is especially true when composing a landscape. Artists talk about learning to see. For me, that magic moment occurred when I learned to shift my vision from all the leaves on a tree and instead, saw a tree as one large shape.

Convey the essence of your inspiration by stretching beyond detailed representation. Simplify all you see in the landscape into ten to twelve abstract shapes. Focus on the big picture and eliminate detail. See shapes, rather than individual objects. Create unity by linking and interlocking shapes like pieces in a jigsaw puzzle. The underlying structure to your painting comes from seeing the landscape in as few shapes as possible.

Create a Strong Composition With Shape Plans

Take out your sketchbook and make thumbnail shape plans of your subject. Vary the format from horizontal to vertical. Draw the outline of the shapes with no detail at all. The more you experiment with different ways to frame your subject, the more original your composition will be. Crop the scene in different ways until you come up with a design that reflects your inspiration from step one. Draw from a variety of angles; come in close on the subject, and view it from far away. Give yourself the time to discover an inspired composition, expressing your response to the landscape. Experiment with a variety of shape plans. If you have drawn more than twelve shapes, take another look. Combine shapes. Take out unnecessary detail. Remember, less is more.

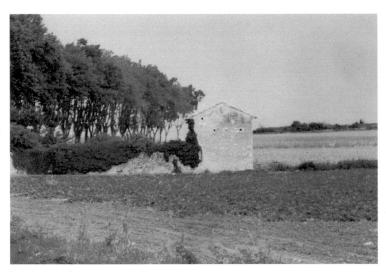

Reference Photo

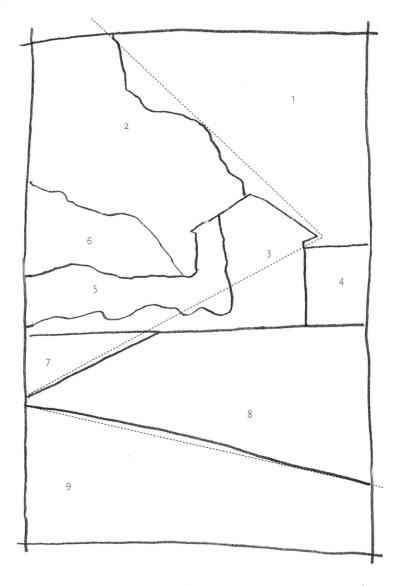

Walk on the Wild Side

I know a wonderful landscape photographer. He can make a familiar scene appear totally fresh by showing the viewer a completely new perspective. His secret is to assume that for the first fifteen minutes all his shots will be the usual, trite responses. After he gets the obvious out of his system, he begins to discover unusual angles. I've seen him crouch down on his hands and knees to shoot up at a sharp angle and jump on top of a stone wall to shoot his subject from above. I follow his advice when plein air painting and assume that my first drawings are going to be the most ordinary ones. I allow myself the time to work past conventional compositions. After my first attempts, I start seeing from a more unique perspective. Give yourself permission to get warmed up and go a little wild. Walk around and explore the landscape for fifteen minutes to allow unexpected viewpoints to arise. Discover the hidden beauty.

Look for an Underlying Design

Select one shape plan from your thumbnails to develop into a painting. Count your shapes—remember no more than twelve. All shapes fit into each other in jigsaw puzzle fashion. Can you find an underlying structural design to your composition? Do all the shapes fit into a larger pattern that ties the whole image together? Look at the dotted lines to see the Z structure that underlies this entire composition. Think about the design as a whole and how all the elements work together.

Value Plan: The Third Step

Make a Music Spiral

Let yourself go in free response to music. Copy the dynamics of music in spontaneous, abstract painting. Start with a mark in the center of a new journal page. Start small and continue adding brushstrokes spiraling out from the center while you listen to the music. Use dynamic music with a lot of tempo changes. As you listen, make marks with a no. 2 round. Use Sumi ink, India ink or Winsor Blue watercolor so that you can clearly record variations in value. When the music comes to a crescendo, signal a focal point by using the darkest value against the white of the paper. When the music is soft and lyrical, place light values together to suggest the musical harmony. When the tempo or dynamics vary, change your brushstrokes. An intricate spiral design will emerge as you visualize the music. Your design will vary dramatically with the music. Try it next with a color triad!

A well-composed painting is half-done. ~ Pierre Bonnard

In step three you turn your shape plan into a value plan. Values are the relative lightness and darkness of a color. They range from the pure white of the paper to the blackest black, and all shades of gray in between.

In music, there are soft, lyrical passages. There are also places where the dynamics are loud and the cymbals crash. The same is true in painting. The value choices you make can create areas of intensity. They can also create passages that sing with a softer, gentler voice.

The eye is attracted to contrast. Wherever you place the lightest light next to the darkest dark, you create a point of interest. In essence, you are crashing the cymbals and banging the drums! Likewise, you create serene sustaining passages when you stay within a narrower range of values.

Build a Value Chart

It's a good idea to make your own value chart to add to your artistic journal for reference. I find it's best to use Winsor Blue, a pigment that can go from very, very light to very, very dark. Draw five squares on a piece of watercolor paper, labeled from 1 to 5 as shown. Start by filling in the square for value 5 with as dark a blue as you can, using Winsor Blue. The darker you can make it, the better. Next, fill in value 3, the middle square. Take your time to match the value in my chart. Next fill in the square for value 4. Your shade should be halfway between value 3 and value 5. Lastly, complete the value chart by filling in the square for value 2. It is halfway between value 1 (white of the paper) and value 3.

3

4

5

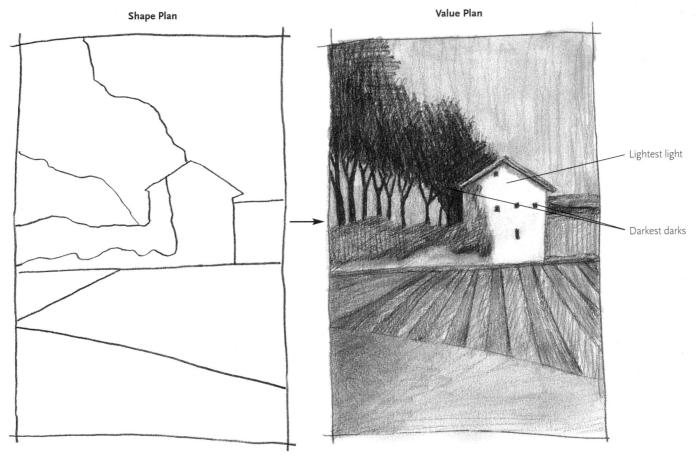

Go From the Shape Plan to the Value Plan

Add shading in pencil to indicate your value choices on top of your shape plan. Put in your darkest values first. Next, add the lightest values. Where they meet is your painting's center of interest. Now add midtones everywhere else. Where there is no shading, you are indicating white of the paper, or value 1. Are you sure that is what you want in that area? Refer back to the brainstorming you did in step one. Does your value plan reflect your original inspiration and working title? Are you bringing the viewer's attention where you most want it? Refer back to your value chart to remind yourself of the full range of values possible.

Using a Red Filter to See Values

Being able to see the highlights, shadows and everything in between is a skill worth learning. A trick I learned from a photographer friend is to use a red filter to view the landscape. Photographers find it useful to previsualize the landscape, obscuring color to mimic the contrast in black and white film. As you look at the landscape through a red fil-

ter, all the value contrasts are heightened. You'll find it easier to see the lightest lights, the darkest darks and all the midtones in between because most of the color information is filtered out. I buy inexpensive clear red acetate at the art supply store and cut a piece into a 6" \times 4" (15cm \times 10cm) rectangle. Tape the

acetate onto the back of an inexpensive $5" \times 7"$ ($13\text{cm} \times 15\text{cm}$) mat with a $3" \times 4\frac{1}{2}"$ ($8\text{cm} \times 11\text{cm}$) pre-cut window. I tuck it into my sketchbook so I have it handy while I'm composing my landscapes. Use what you learn by looking through the red filter when making your value plan.

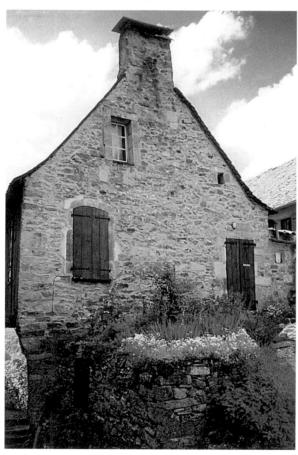

Turn Your Inspiration Into Shapes

This is a photograph I took while on a painting vacation in the Dordogne region of France. I was attracted to the irises growing like purple flags in the pocket garden in front of the house. I had a little bit of time to draw and paint, so I pulled out my sketchbook. I spent a few minutes brainstorming what appealed to me about this village house. I realized I loved the contrast between the rugged stone construction and the brilliant, fresh, dewy iris garden tucked into the front of the house. Next, I got started making thumbnail shape plans. I chose one to develop further into a painting.

Identify Values With a Red Filter

I was ready to make my value plan. I pulled my red acetate filter out of a pocket in my sketchbook to see the values in this scene more clearly. I'm glad I had my red filter with me while I was on location because it helped me make a value sketch. I was able to see how the light flowers in front of the irises stand out from the darker foliage behind them. Also, it helped me notice the dark value of the wooden shutters and door set against the stones of the house.

Moving From Landscape to Painting

The landscape artist has the ability to transform reality to better communicate an emotional response. I often elect to make my own value choices when painting a landscape. You can bring the viewer's attention to any aspect of your painting by simply pumping up the value contrast.

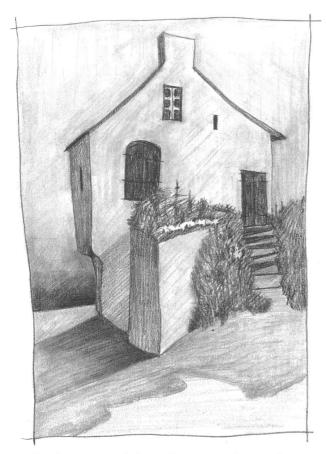

Add Values on Top of Shapes in Your Artistic Journal

Here's my on-location value plan, which I drew on top of my shape plan. I wanted to be sure to get the shapes of the shadows as they danced across the lane and in front of the house. On reflection, I see that I didn't include the clouds in my drawing. If I paint this scene again, I think I will include the dramatic cloud formations in the photograph. You can always paint the same scene more than once.

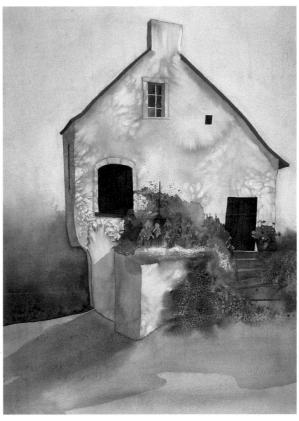

Put Inspiration Into Your Painting

This is my finished watercolor, *Village House With Irises*. Everything came together because of creative planning. I feel relaxed when it comes to painting, and simply enjoy myself, because I have a plan and know how I am going to proceed. The success of a painting very often has little to do with the actual time spent painting. Rather it has more to do with the time taken to plan your painting so you know how to go forward without anxiety. No plans are rigid, however, and adjustments happen as you dive into the creative process.

Color: The Fourth Step

Make a Triad Sampler

Start with a quick landscape sketch on a journal page with a .50mm or wider felt-tip pen. Make four photocopies of your drawing on white cover stock. Paint each photocopied sketch with a different triad. Apply the paint loosely on top of the drawing. Splash on color mixtures to reveal the personality, temperament and possibilities of each color triad. Don't forget to make note of the triad you used for each painting. When dry, add your triad samplers to your journal. Use the slit method described on page 115 and you will be able to remove your four triad paintings for future color reference. You may need to trim the cover stock to fit your journal page. See if you feel the same way about the personality of the four triads as I do. Do my descriptions of each triad hold true for you? If other labels work better for you, use them.

It is not pure fantasy to say that the color red is like the sound of a trumpet.

~ Joyce Cary

Painting on-location is an art form of the moment—best done quickly before the light changes or you get uncomfortable. I always paint with triads when out-of-doors. Triads are a creative shortcut to vibrant color blends. With just three well-chosen pigments, I am confident of eye-catching and harmonious color mixes. The best part about painting with triads is that each of them conveys a different mood. Becoming familiar with the characteristics of each triad gives you a powerful catalyst for color expression. Each trio of pigments is a connoisseur's recipe for creating atmospheric colors and an eloquent way to convey your original inspiration.

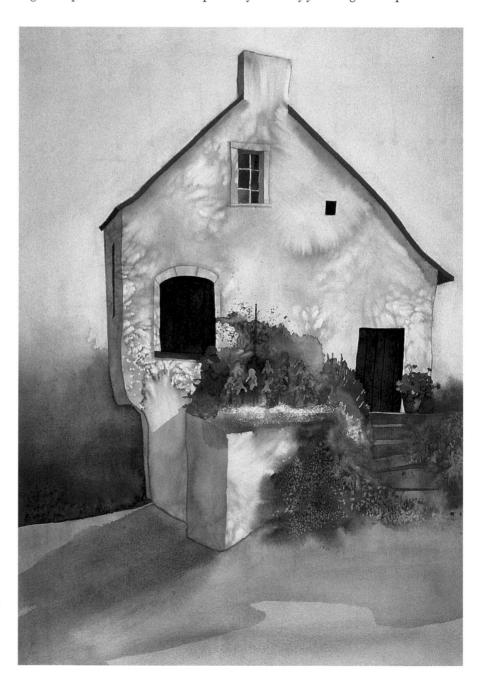

Triads Have Attitude

I painted the watercolor, Village House With Irises, using my sun triad. I knew before I started painting that this trio of pigments would create sun-drenched color blends—luminous violets, yellow-oranges and greens. It gave me confidence to know that all my mixes would be well balanced and communicate the mood of this summery scene.

Capture the Mood With Color Triads

Each triad interprets the landscape in a unique way. Marry the color mood of your watercolor with the emotional message you want to send to the viewer through your choice of triad. Painting with the three limited colors of a triad has the advantage of keeping the whole painting harmonious. Indeed, in some cases, you won't be able to mix a match for the local color you see from the pigments in your triad. This is not a limitation! It is an invitation to paint

passionately, rather than photographically. Put your personality into your painting, and let the viewer know what you feel about your subject, rather than merely reproducing it.

Full-Spectrum Triad

Water Triad

Sun Triad

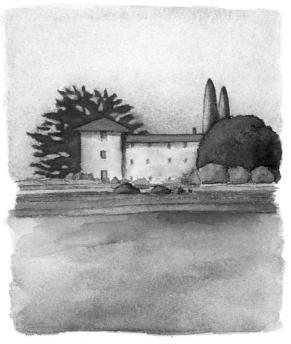

Earth Triad

Triads Have Personality!

My palette is made up of twelve colors that form four different triads. I call them the full-spectrum, earth, water and sun triads. As I got to know each triad, it became clear to me that each one possesses an essentially unique personality. The way the pigments blend, mix and marry within each trio of colors creates an unmistakable atmosphere and mood. I realized I had unlocked a marvelous tool for self-expression. I gave the triads names corresponding to their color personalities.

Later I realized that these names echo the ancient world's understanding of the four elements of the universe—air, earth, water and fire. However, don't take these labels too literally. The sun triad is a lot more than yellows and oranges. The water triad is a lot more than blues and grays. And, the earth triad is a lot more than greens and browns.

Earth Triad

- Holbein Cadmium Red Light or Winsor & Newton Cadmium Scarlet

Characteristics: Minerals, stones, tile, bricks, cliffs, soil, mountains, weathered texture, dusty, sandy, fields, farms, plant life, orchards, weeds, natural elements, wood, texture, grasses, strength, groundedness, calm, terra firma...

Full-Spectrum Triad

- Winsor & Newton Winsor Lemon or Holbein Permanent Yellow Lemon
- M Holbein Permanent Rose or Winsor & Newton Permanent Rose

Characteristics: Multihued, fullness, airy, wind, abundance, potential, promise, horn of plenty, cornucopia, rich, profusion, treasure, fruitfulness, vigor, transparency, clear light, optimism, clarity, luscious, succulence, wholeness, fulfillment, well-being...

Water Triad

- Winsor & Newton Ultramarine Violet

Characteristics: Watery, moist, misty, foggy, coolness, drizzly, hazy, vaporous, cloudy, dewy, low light, waterways, forests, dawn and dusk, less focused, underwater, subterranean, mysterious, secretive, deep, silent, moonlit...

Construct a Color Library

One good way to get to know the triads is by making a color library of each one in your sketchbook. Open to a new page and paint each pure pigment at the three points of a triangle. Fill in the triangle with blends and mixes in between the pure pigments. Discover for yourself the temperament and spirit rooted in each one. Identify some characteristics of your own. Does one triad speak to you more than the others? For more ideas on color libraries, see page 30.

Sun Triad

- ₩ Winsor & Newton New Gamboge or Holbein Gamboge Nova

Characteristics: Warmth, floral, sun-drenched, foliage, blooming, meadows, deserts, wildflowers, sun and shadow patterns, bright sunlight, fire, comfort, luminous light, joyful, pleasure, active, lush, velvety, burnished, radiant, flamelike, aglow, candlelit, golden, vivid...

Glet to Know the Full-Spectrum Triad

The Full-Spectrum Triad

- Winsor & Newton Winsor Lemon or Holbein Permanent Yellow Lemon

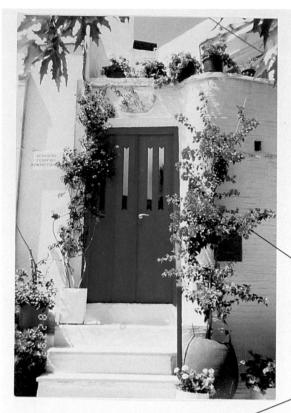

Step 1 Inspiration

my four steps.

The flowers and pots stood out in exuberant contrast to the stark white walls of this village house. After a few pleasant moments' reflection, I gave my painting the working title of *Dancing Pots*. I took a photograph for reference and later added it to my journal page.

Using the Full-Spectrum Triad and the Four-Step Plan This is a page from my one of my travel journals to Greece. You can see how I made visual notes as I progressed through

Steps 2 and 3 Shape and Value Plans

My composition took form as I sketched a small shape plan in pencil. When my shape plan was complete, I shaded my sketch to make my value plan.

Step 4 Color Triad

I made color notes to help choose the best triad to express my feelings about this scene. The full-spectrum triad had all the characteristics I needed to express the profusion of energy in this lively doorway.

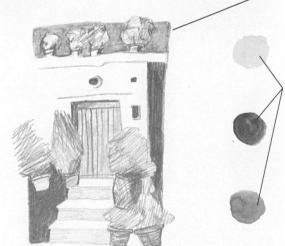

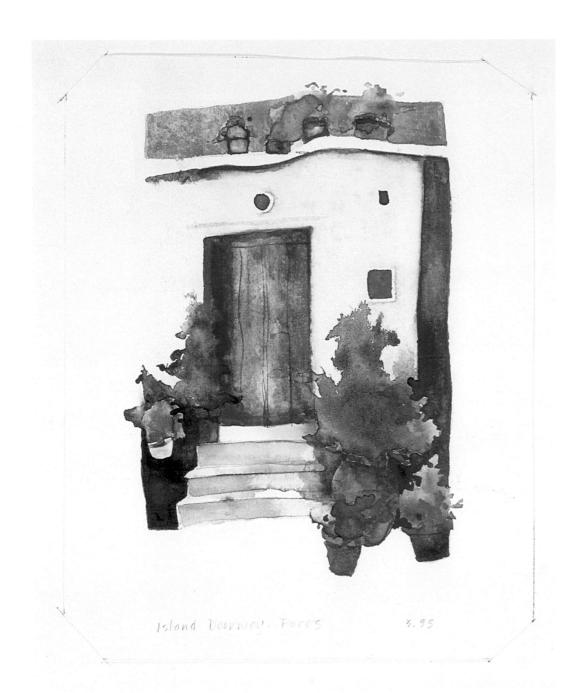

Four Steps and the Full-Spectrum Triad Makes Plein Air Painting Fun

My journals are filled with small, playful watercolor paintings, which are often the inspiration for larger works completed back home in the studio. I cherish my travel journals as a resource book of ideas. My four steps help make painting outdoors a carefree and satisfying experience. Here is my painting *Dancing Pots* from my Greek travel journal.

Note how slits cut in the journal page with a craft knife support the painting done on a separate sheet of watercolor paper. This simple technique allows you to safely insert paintings into your artistic journal without degrading them with adhesive.

Giet to Know the Earth Triad

The Earth Triad

Turn a New Leaf

Take an artistic ramble to collect leaves, twigs, flowers, weeds and other natural treasures. Every season offers its own special bounty. When you are back in the studio, sort through your collection and select a few to paint. Place each object directly on top of a new page in your journal. Play with the position of your botanical finds until you find an arrangement you like. When you are satisfied with your composition, simply hold each object in place and trace around the outside edges with a no. 2 pencil. Remove the objects after tracing them. Add watercolor to your drawing by using the earth triad to mix the rich colors of your nature study.

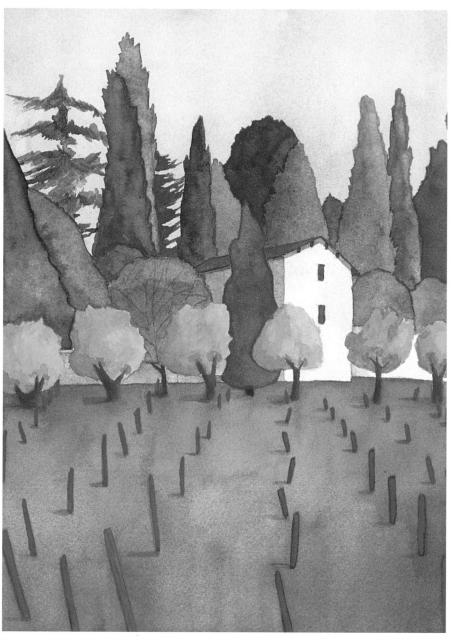

Express the Essence of the Scene With the Earth Triad

I love the way painting with a limited palette encourages color choices that aren't a photographic match for the landscape, but instead lead me to make more personal, emotional choices. I gave myself permission to play with color in this watercolor, and use nonlocal colors for the trees, the vineyard stakes and the soil in the foreground. I knew that by using the earth triad, I would end up with a harmonious combination of colors, all conveying the richness of this vineyard scene.

VILLA MONTE SOLARE, PERUGIA
Watercolor on Arches 140-lb. (300gsm) cold-pressed paper
7" × 11" (18cm × 28cm)
Collection of Laura Kanter

Use the Earth Triad

MATERIALS

Bamboo pen
Arches 140-lb. (300gsm) cold-pressed
paper, cut to fit inside sketchbook
Earth triad pigments Cadmium Scarlet,
Permanent Green #2, Ultramarine
Violet

Facial tissues
Nos. 4 and 6 rounds

The earth triad helped me to create beautiful colors—all summoning up this robust, natural environment. Paint this landscape yourself to learn how painting with triads helps you understand color by painting with a limited palette. When painting a landscape, a rule of thumb is to paint the most distant areas first.

Paint What Is Furthest Away

Wet the whole sky area with clean water. Then brush on diluted Schmincke Ultramarine Violet with a no. 6 round. Use a clean, dry tissue to lift some of the wet paint to suggest clouds.

Dilute a mixture of Winsor & Newton Cadmium Scarlet with Schmincke Ultramarine Violet and brush it over the entire mountain area with a no. 6 round. Suggest grassy areas by dropping in diluted Holbein Permanent Green #2 tinted with Winsor & Newton Cadmium Scarlet on some of the mountains while they are still wet. When dry, add shadows to the mountains with a darker shade mixed from Ultramarine Violet and Cadmium Scarlet.

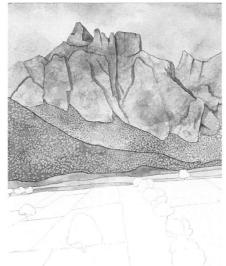

Texture the Foothills With Salt

Paint the green foothills with a mixture of Holbein Permanent Green #2 and Winsor & Newton Cadmium Scarlet with a no. 6 round. Sprinkle each area with salt while it's still shiny wet to create a textured surface to suggest forests and shrubbery.

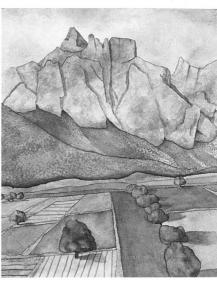

Paint the Fields and Trees

Paint the farmland in the valley. Use unmixed Holbein Permanent Green #2 in the bright yellow-green fields. Create redbrowns by mixing Winsor & Newton Cadmium Scarlet and Schmincke Ultramarine Violet, touched with just enough Holbein Permanent Green #2 to brown it. Scratch a pen nib into the surface of the wet paint to create dark lines for rows and furrows. Paint the trees green, created with Holbein Permanent Green #2 and a bit of Schmincke Ultramarine Violet to cool it down. Use pure Schmincke Ultramarine Violet for the shadows of the trees.

Glet to Know the Water Triad

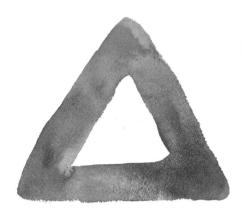

The Water Triad

Studio on Wheels

Inclement weather does not have to be an obstacle to the plein air painter. Fog and rain are commonplace where I live, but even during the wet months, I can still satisfy my urge to paint on site. My secret is to get in my car and drive to a scenic spot. All I do is point my car in front of an inspiring landscape and set up my studio on wheels. Fill your car's cup holders with a cup of water for painting and a cup to hold your brushes. Lay out your drawing and watercolor tool kits on the passenger seat. Bring along some CDs or tapes to play while you explore the four seasons, good weather or not. Try out the water triad as you paint during a rainstorm, cozy and warm in your portable studio. It's fun to be a foul weather painter.

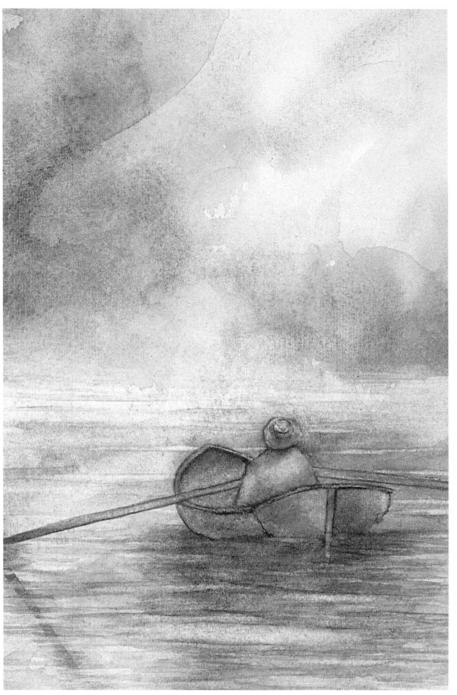

Make Watery Watercolors With the Water Triad

One of the great things about triad painting is that when you become familiar with the personality of each one, it takes no time to make color choices. This is a page from one of my artistic journals. I wanted to make a watercolor sketch of a lone fisherman at a nearby lake on a brisk fall day, but I didn't want to spend a long time outside getting cold. I knew that the water triad would help me convey this misty scene. In essence, I let the watercolor pigments do some of the interpretive work for me. I painted the whole piece of watercolor paper with a soft, loose wash of the three water triad colors. After it dried, I sketched the fisherman in his canoe in pencil and then painted in the shapes.

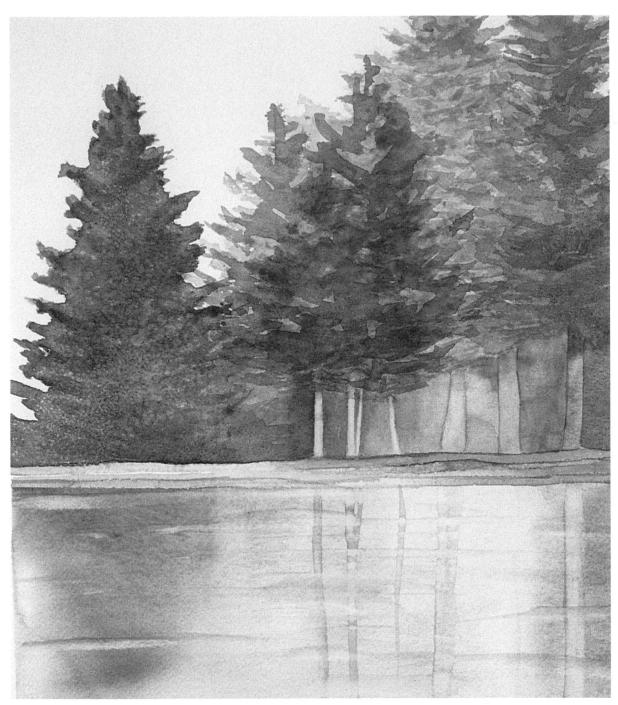

Paint the Foggy, Foggy Dew

This watercolor explores the silvery, hazy quality of sunrise in an Oregon forest. The water triad conveys the soft, unfocused light of early morning, peeking between dense old-growth fir trees. The feeling of coolness and wetness in this palette lends itself to expressing water and reflections in a dewy way. The fir tree at the left was painted with a mixture of Holbein Viridian and Winsor & Newton Ultramarine Violet. I sprinkled salt on the wet paint to give the tree shape some texture and an illusion of depth. The water was painted all in one try. When dry, I added reflections of the tree trunks in the water. I then ran a clean no. 4 round horizontally across the reflections in the water, and gently lifted off some of the pigment to suggest ripples.

Glet to Know the Sun Triad

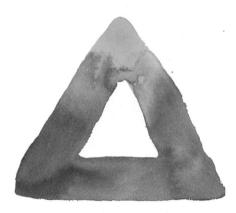

The Sun Triad

- Winsor & Newton Permanent Magenta or Holbein Permanent Magenta
- Winsor & Newton New Gamboge or Holbein Gamboge Nova

Great Expectations

Fuse expectation with experience in a twopart journal exercise. Before going to an artistic event, open to a new page in your journal, and draw in pencil for just five minutes. Briefly record something about the upcoming event. There are no rules. Just draw whatever comes to your mind about the movie, concert, art exhibition, dance performance, lecture or museum you are going to see. After it is over, embellish and modify your preconception drawing. Erase, or go on top of your original pencil drawing, adding new or revised images. Use felt-tip pens to highlight the final drawing. Then choose a triad to add color. This exercise reveals the evolution of perception. Experience a heightened focus of attention during an event as you anticipate further reflection in your journal afterward. It helps me hold onto the beauty of a dance, the lilt of a song and the creativity of the artist.

Paint Sun and Shadows With the Sun Triad

This is a little watercolor sketch made in the south of France, painted on a page in my travel journal. The color mixing was easy for me. I knew that the sun triad would help me convey the warmth of this sunlit scene. I could depend upon the harmony of the color mixes to fashion an atmosphere corresponding to what I most enjoy in the south of France—the strong light, olive trees, cypress trees and houses with tile roofs kissed by the sun on one side and bathed in warm shadows on the other.

The Landscape Is Aglow With the Sun Triad

Triadic painting means that you can quickly match the mood you want to convey in your paintings with specific color combinations. I wanted to capture the strong afternoon light and shadows of Provence, therefore I used the sun triad in this watercolor. Permanent Magenta and New Gamboge combine brilliantly for the rich orange of the painted stucco walls of the building. I sprinkled a little salt onto the wet paint for a textured look. It was a breeze to create the blues of the sky and the sign, using Marine Blue with a touch of Permanent Magenta. The dark green of the doors and shutters was created by mixing Marine Blue and New Gamboge to make a blue green, then adding a touch of the third pigment in the triad (Permanent Magenta) to gray it. The sign on the building says it all—"Paint in Provence" (with the sun triad).

My Color Palette

My palette is made up of just twelve pigments, one for each of the hues of the traditional color wheel. Each of the triads is balanced evenly around the color wheel. The idea is to keep it simple with twelve versatile and well-chosen pigments. From these twelve pigments, you can literally mix any color.

Each of these pigments has excellent lightfastness for color durability and longevity. I'm reminded of what J.S.

Bach said of his son, C.P.E. Bach, "His music is Prussian Blue: it fades." In those days, apparently Prussian Blue was not lightfast.

Another important quality of my palette is that each of these pigments is a pure color. Painting with pure pigments is essential to mixing vibrant colors. When you mix two colors together, you want to know that you

are mixing just those two colors. For example, to get a brilliant violet, you mix together red and blue. With premixed pigments, there are colors other than pure red in your red pigment, and colors other than pure blue in your blue. You are actually mixing more than just red and blue together, you are mixing trace amounts of other colors that dull the brilliance of your violet.

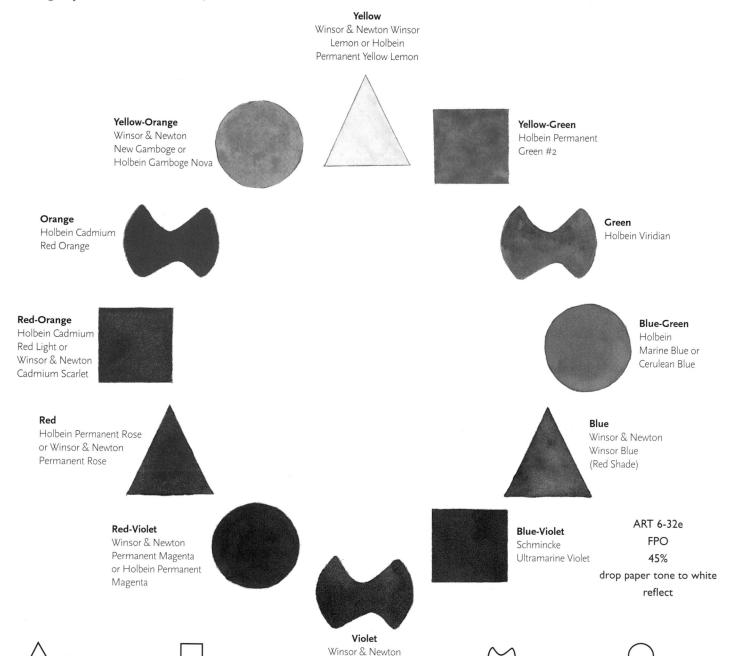

Ultramarine Violet

Full-Spectrum Triad

Earth Triad

Perfect Complements Create Perfect Blacks

Color theory tells us that any complementary pairs mixed together create black. Complements are those pigments that are directly opposite each other on the color wheel.

Over the years, friends, students, friendly art supply stores and paint

manufacturers have all offered me dabs and tubes of paint to try. When I eventually found just the right twelve pigments, I shouted "Eureka! I've got it!" Each pair of complements makes a perfect black.

You may want to replace a tube of

paint for one that is close in color to one in my palette. There is an easy litmus test to see if your pigment is an accurate color substitute. Mix your pigment with its complement, and see if you, too, get black. If so, you have found a substitute.

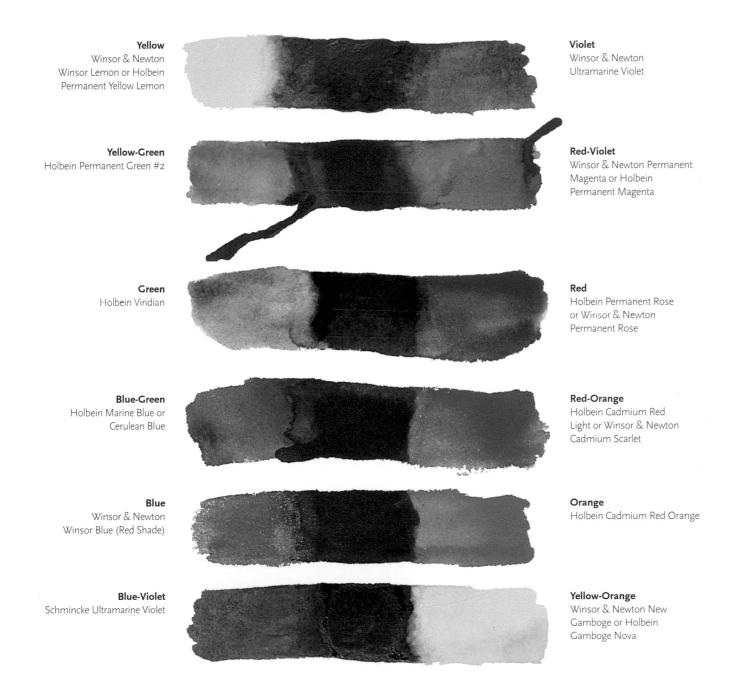

The Palette Layout

My palette is like a good friend. It has been with me all over the world, and is the same one I rely on in my studio. I always use the Jones Color Round watercolor palette. It is specifically designed for the twelve pigments of the color wheel. This feature is a big help to the watercolor painter. You can purchase this palette at most fine art supply resources.

Make Your Own Template

If you are using the palette I use, the Jones Color Round palette, you will want the template to be 7" (18cm) in diameter. If you are using a different palette, measure the diameter of that palette to determine how large to make your template. When your template is made, have it laminated for extra durability. Cut out the large outside circle of the template and the three small pigment circles with scissors. Use the black lines as a guide. Place the template over the palette. Now you are ready to pick a triad and experience the freedom of triadic painting.

Organize Your Pigments in a Circle

I've used this palette for years and love its color wheel organization, size and portability. To make it totally portable, fill each well with the correct pigment and let the paint dry until hard. Be patient, this thorough drying process can take a few days. When completely hardened, there are no dripping paint messes to worry about. When I'm ready to use a pigment, I spray it lightly with water to soften the paint.

Isolate the Triads With a Template

I designed my triad template to fit on top of my palette. As you rotate the template, you expose just the three pigments of each triad.

I love to visually isolate the colors of each triad. This prevents me from accidentally sticking my brush in the wrong well when in the whirl of painting. The less I have to think in a logical and linear way, the more I am free to be creative. All my planning comes before I start painting. My triad template is the secret to painting without working to remember which pigments are included in the triad.

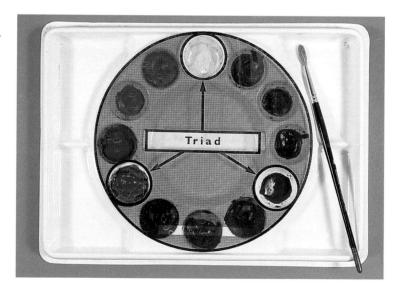

Conclusion: Be an Art Explorer

The artist is an explorer—both of things you can see, and things you can't see. Explorers make fantastic discoveries, but they also sometimes reach a dead end. This is a natural part of the process. As an art explorer, I give myself permission to take risks, reach dead ends and try new things that don't always work out. That is the special privilege of the private experience in the artistic journal. Think of your journal work as exploration, rather than accomplishment, and discovery, rather than achievement. You never know what new worlds you will find when you embark on an uncharted art journey. Use your artistic journal to make private, personal art. You don't need to share it with the public unless you choose. Explore your creativity wholeheartedy, and most importantly, relax. Open your journal, fill a page every day, and allow the magic to happen.

Final Thoughts

- Break the rules and take artistic liberties. Paint the sky yellow, the trees purple, the grass orange and the water red!
- The art critic is on vacation—toss judgement out the window. Nothing squelches creativity more than the daunting expectation of perfection.
- Have fun! Experiment with what you already know, and extend it into the unknown. Liberate yourself from predictability. Open up to the exhilaration of discovery.

Dive In, the Water's Fine!

Take the plunge and explore your creativity from the inside out. Pay attention to what captures your interest on a daily basis. Use your journal to make artistic gestures reflecting the pulse of your life. This is the rhythm and music of what is meaningful to you, and it contains the symbols of personal imagery. These two watercolor paintings are a good example. They came about after reading recent newspaper articles about the plight of salmon in the Northwest United States. I made some visual notations in my artistic journal, and from that a series of paintings evolved.

BLUE FISH, BLUE WATER
Watercolor on crinkled Masa paper collage on Arches 140-lb. (300gsm) cold-pressed
watercolor paper
7° × 10° (18cm × 25cm)

BLUE FISH, RED WATER
Watercolor on crinkled Masa
paper collage on Arches 140-lb.
(300gsm) cold-pressed paper
7" × 10" (18cm × 25cm)
Collection of Teri Wadsworth and
John Paul

٨	pointing post the photo and 30	Framing
A	painting past the photo and, 39 for triads, 113	Framing
Artistic journal, 11–13	Color palette, 122	creative, 59
cover, 13	Color triads, 110—121	panoramic, 70, 72–73 Frontspiece, 13, 55
facing pages, 13	capturing mood with, 111	Full-spectrum triad, 111, 112, 114
first letters of pages, 13	earth triad, 111, 112, 116—117	1 un spectrum triau, 111, 112, 114
frontspiece, 13, 55	full-spectrum, 30–31, 111, 112, 114	1-
inserting paintings into, 115	isolating, with template, 124	G
private art in, 11, 125	sun triad, 110, 111, 113, 120–121	Garden, bird's-eye view of, 60–63
Artistic liberties, 3 ₇	water triad, 111, 113, 118—119	Glue, white, 19
_	Cover, journal, 13	Glue brush, 19
В	Craft knife, 19, 83	Glue stick, 19
Background	Creative matrix, 44–47	Gold leaf, 57
colors against white, 86	Creativity	
eliminating, 68	planning for, 13	H
landscape, 68–69	simplicity as catalyst for, 15	Hearing, sense of, 74
with prismatic painting, 34	Crinkled paper collage, 94–97	ricaring, serise or, 74
Bamboo pen, 20	drinkled paper conage, 94, 97	~
Bird's-eye view perspective, 60–63	Γ	K
Black, complements and, 123		Keyhole paintings, 70
Blending stump, 18	Dishtowel, 20	Knife, craft, 19, 83
Border, doodle, 42	Doodling	
Botanical studies, 96, 116	creative, 42–43	<u></u>
Brayer, 19	personal symbols in, 43	Laminating paper, 16
Brushes, 20	Drafting tape, 16	Landscape
	Drawing	color triads and. See Color triads
	loop, 28	composing, 68
	one minute, 24–25	emotional response to, 102–103
Café art, 34	overlapping, in sketchbook, 26	foggy, 119
Caricature doodle, 42	pencil, 24	moving to painting from, 109
Click eraser, 18	trying different tools for, 25	room-with-a-view painting, 52
Collage	Drawing tool kit, 18	seven paintings from one, 69
colorful background blanket for, 88–89	Dry mount glue technique, 84–85, 91	shape plan for, 104–105
crinkled paper collage, 94–97		value plan for, 106–107
found object, 98–99	E	See also Painting outdoors
mosaic art, 80–85	Earth triad, 111, 112, 116–117	Loop drawing, 28
painted paper cutouts, 86–87	En plein air, 102. See also Painting outdoors	Loop drawing, 20
paper weaving, 90–93	Eraser, click, 18	٨٨
spontaneity with, 79	Events	M
Collage paper, 16	honoring, in artistic journal, 12	Matrix, creative, 44–47
Collage tool kit, 19	recording artistic, 120	Mechanical pencil, 18
Color	recording artistic, 120	Metallic marker, 18
brights, 31	F	Metallic pen, 19, 83
collaging, 33	•	Metric conversion chart, 4
complements, 123	Facing pages, 13	Middle ground, 68–69
contrasting brilliant against white, 86	Felt pen, 18	Mosaic art, 80–85
darks, 31, 39	First paint, then draw method, 32	dry mount glue technique, 84–85
embellishing drawings with, 25	Fixative, 18	watercolor mosaics, 80–83
grays, 31	Foreground, 68–69	Mounting tabs, 16, 57
pure pigments, 31	Format	Music, free response to, 106
shades, 31	open page, 26–27	
Color library	small frame, 24	
defined, 30	Found object collage, 98–99	

^	new, for landscape, 105	Straightedge, 18
Observations	one-point, 60–63	Sun triad, 110, 111, 113, 120–121
Observation	panoramic, 70–73	Supplies, 15–21
areas of, for creative matrix, 47	sensory, 74–77	collage tool kit, 19
icons, 56–57	two-point, 64–67	drawing tool kit, 18
One minute drawing, 24–25	Photograph	sketchbook portfolio, 16–17
turning into painting, 29	adding elements beyond, 37–39	watercolor tool kit, 20
One-point perspective, 61	isolating narrow slice of, 70	
Open page format, 26–27	softening borders of, 36	T
Outdoor painting. See Painting outdoors	tracing figures from, 66	
D	Piazza, two-point perspective of, 64–67	Tape, drafting, 16
r -	Prismatic painting, 34–35	Taste, sense of, 75
Painting	Private art, 11, 125	Three dimensions, 64
moving from landscape to, 109		Thumbnail shape plans, 104–107
turning one minute drawing into, 29	R	Title page, 55. See also Frontspiece
windowpane, 48–51	1.3	Toothbrush, 20
Painting outdoors, 101–121	Red filter, 108	Touch, sense of, 75
color and, 110–121	Reference material, 29	Travel art tips, 54–55
inspiration from, 102–103	Room-with-a-view painting, 52–53	
inclement weather and, 118	Rubber cement, 19	U
See also Landscape	Rubber cement pick up, 19	Underpainting
Painting past the photo, 36–39		atmospheric, 32
Palette	5	at edges of photo, 38
color, 122	Salt shaker, 20, 83	at edges of photo, 50
watercolor, 16	Scissors, 19	\ /
Palette layout, 124	Scratching, 83	V
Panoramic perspective, 70–73	Scribbling, 35	Value chart, 106
Paper	Sensory perspective, 74–77	Value plan, 106–107
collage, 16	Shading, smudge, 28	on-location, 109
crinkled, 94	Shadows	Values
Japanese Masa, 94	patterns, 60, 63	filter, 16
laminating, 16	sun triad and, 120	red filter and, 108
preserving white of, 68	Shape plan, 104–105	on top of shapes, 109
scraps, 16	Shapes, values on top of, 109	Vanishing point
watercolor, 16	Sight, sense of, 76	in one-point perspective, 61
Paper cutouts, painted, 86–87	Simplicity	in two-point perspective, 65
Paper weaving, 90–93	creativity as catalyst for, 15	
Pen	windowpane painting and, 48	\mathcal{W}
bamboo, 20	Sketchbook	Water triad, 111, 113, 118–119
felt, 18	habit, 23	Watercolor mosaics
fine vs. wide lines, 33	overlapping drawings in, 26	backgrounds for, 82
gel, 18		texture with, 83
metallic, 19, 83	portfolio, 16–17	Watercolor palette, 16
Pencil	restaurant drawings in, 26	
mechanical, 18	Sketchbook journal	Watercolor paper, 16
soft (2B), 28	impressions of landscape in, 103	color and texture on, 84
watercolor, 20	thumbnail shape plans in, 104–105	for paper cutouts, 87
Pencil drawings, 24	Small frame format, 24	Watercolor pencil, 20
Personal art, 125	Smell, sense of, 76	Watercolor tool kit, 20
Perspective	Smudge shading, 28	Wet-in-wet technique, 32, 35
artistic journal and, 59	Spattering, 83 Sports, panoramic paintings of, 71	White glue, 19 Windowpane painting, 48–51
bird's-eye view, 60–63	Spray bottle, 20	"muo "pane panning, 40–51
	Spray Double, 40	

The best art instruction comes from North Light Books!

These books and other fine North Light titles are available from your local art & craft retailer, bookstore or online supplier.

The biggest roadblock to any artist's success is the intellectual brain. In this easy-to-follow guide, readers will learn to silence their enemy within so they can listen more clearly to their visual brain.

ISBN-13: 978-1-58180-993-0 ISBN-10: 1-58180-993-X, paperback, 128 pages, #Z0942

you gauge your

Celebrate

Greative

Freative

Self

more than
25 exercises
to unleash
the artist within

This book shows you how to develop the skills you need to express yourself no matter what unique approach your creations call for! Experiment with and explore your favorite medium through dozens of step-by-step mini-demos. No matter what your level of skill, Celebrate Your Creative Self can help make your artistic dreams a reality!

ISBN-13: 978-1-58180-102-6 ISBN-10: 1-58180-102-5, hardcover with concealed spiral, 144 pages, #31790

Acrylic Revolution addresses the most popular applications of acrylic in order to improve your acrylic painting process. Over 101 of the most popular, interesting and indispensable tricks are demonstrated and a gallery of finished art will show you how to combine the different tricks for real-life applications.

ISBN-13: 978-1-58180-804-9 ISBN-10: 1-58180-804-6, hardcover with concealed spiral, 128 pages, #33483 BERT DODSON

-55 specific keys to Improving your drawings
-8 self-evaluation
-8 self-evaluations.

Bert Dodson's successful method of "teaching anyone who can hold a pencil" how to draw has made this tome one of the most popular, best-selling art books in history-an essential reference for every artist's library. Inside you'll find a complete system for developing drawing skills, including 48 practice exercises, reviews, and self-evaluations.

ISBN-13: 978-0-89134-337-0 ISBN-10: 0-89134-337-7, paperback, 224 pages, #30220